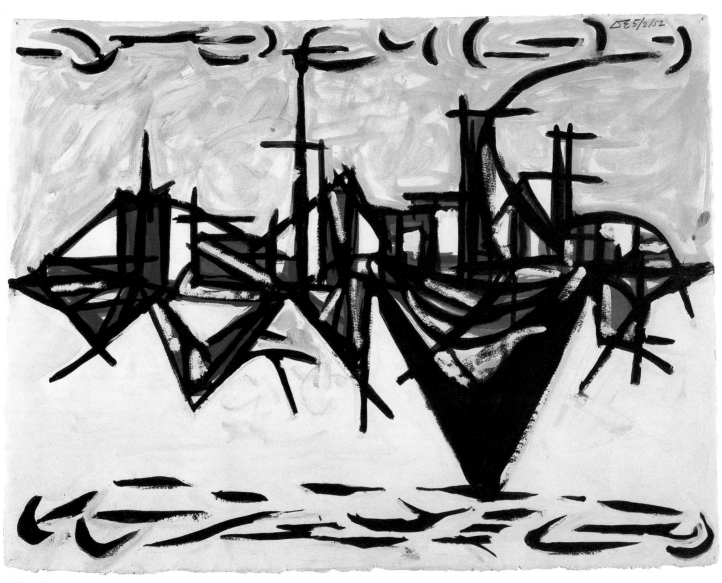

Color plate 1

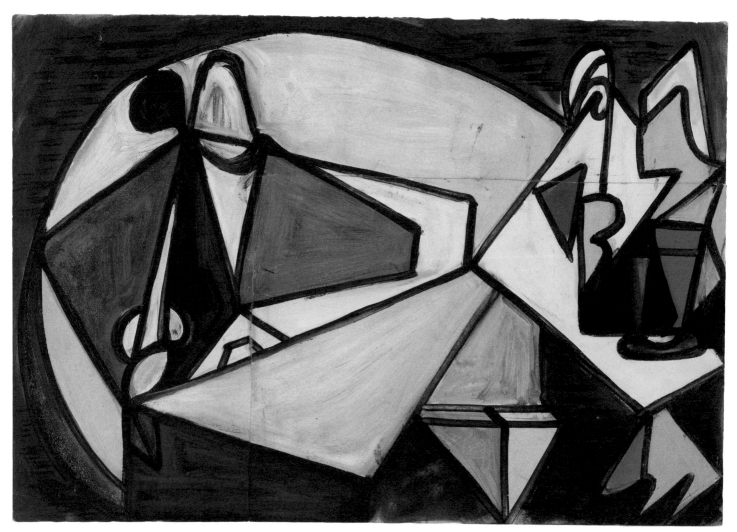

Color plate 2.

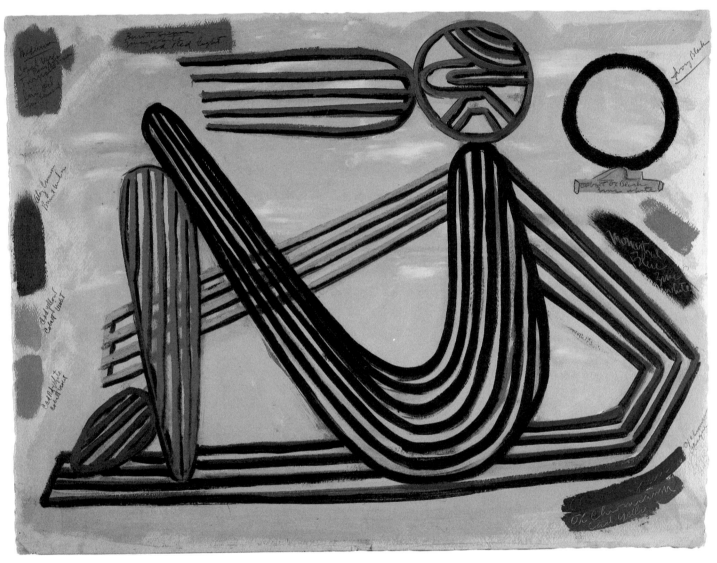

Color plate 3

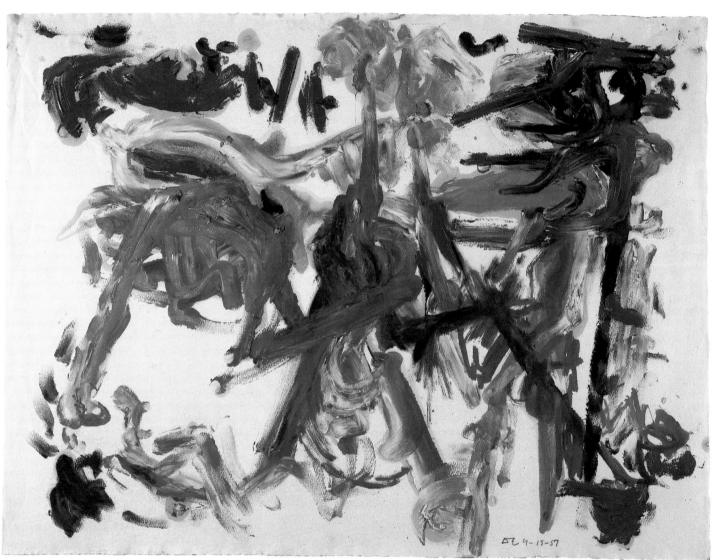

Color plate 4

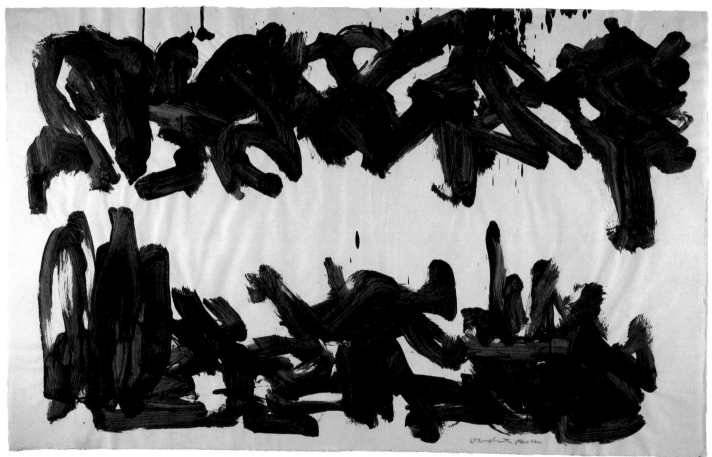

Color plate 5

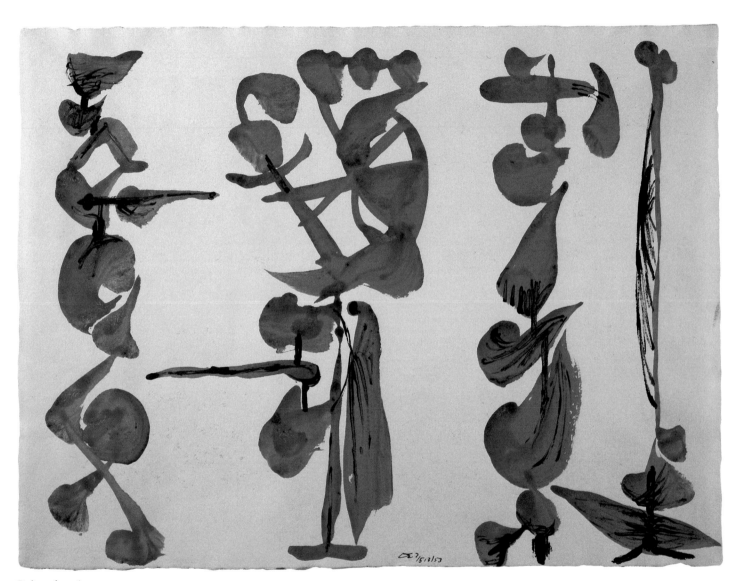

Color plate 6

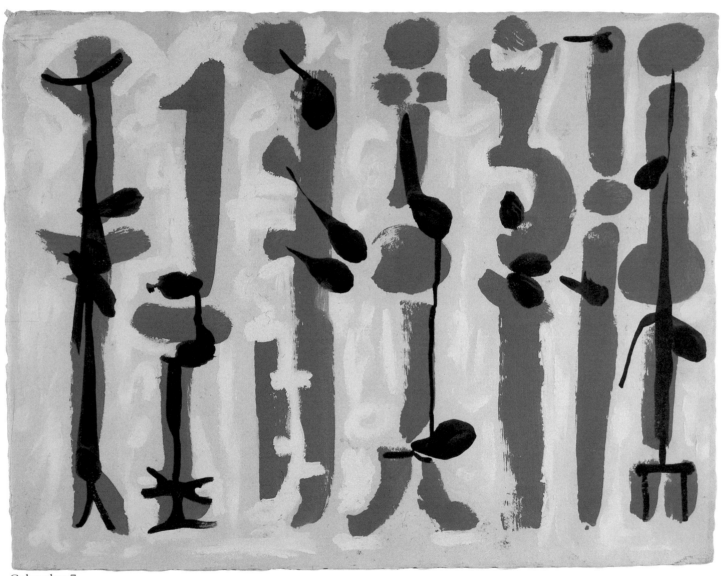

Color plate 7

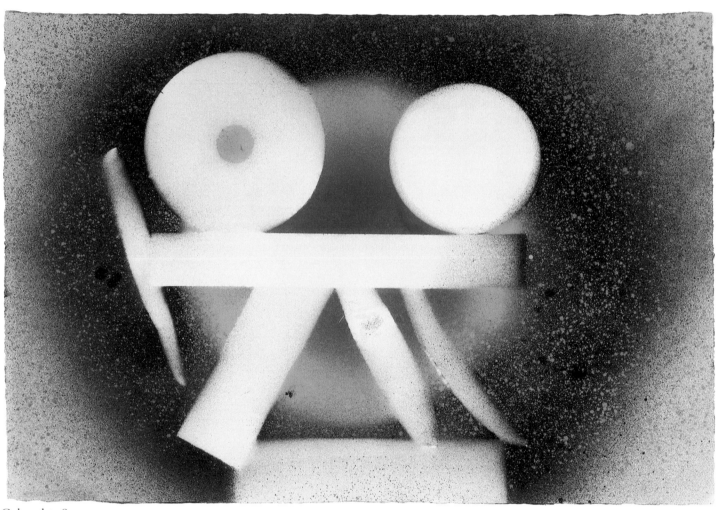

Color plate 8

THE DRAWINGS OF DAVID SMITH

TRINKETT CLARK

Organized and Circulated by the International Exhibitions Foundation, Washington, D.C.

Color plate 1. $\Delta\Sigma$ *5/2/52*, 1952. (No. 14)

Color plate 2. *Untitled*, c. 1934 (No. 21)

Color plate 3. *David Smith 1946*, 1946. (No. 27)

Color plate 4. $\Delta\Sigma$ *9-18-57*, 1957 (No. 50)

Color plate 5. *David Smith 1960 Ch*, 1960 (No. 55)

Color plate 6. $\Delta\Sigma$ *7 / 5/3/53*, 1953 (No. 60)

Color plate 7. *Untitled*, 1953 (No. 65)

Color plate 8. *Untitled*, 1962. (No. 76)

This exhibition is organized and circulated by the International Exhibitions Foundation, Washington, D.C.

©1985 the International Exhibitions Foundation, Washington, D.C.
Library of Congress Catalogue Card No. 85-080543
ISBN 0-88397085-6

Designed by Keith Davis.
Produced for the International Exhibitions Foundation by The Arts Publisher, New York.
Composed in Bembo with Trade Gothic Bold Condensed.

ACKNOWLEDGMENTS

It is indeed a privilege for the International Exhibitions Foundation to present "The Drawings of David Smith." One of the most prolific artists of the twentieth century, Smith is known primarily for his contributions to modern sculpture. His achievements in drawing and painting have only recently received the recognition they deserve, and this exhibition is the first comprehensive showing in the recent past of his works on paper. The eighty-four drawings illustrate the diverse nature of Smith's work and include early figure studies and landscapes, Cubist and Surrealist works from the 1940s, fluid abstractions from the 1950s, and sprayed works from the 1960s.

We are particularly indebted to Candida and Rebecca Smith, who graciously agreed to lend these works by their father for the duration of the tour. Their generosity and enthusiasm assured the project's success. Our guest director, Trinkett Clark, deserves special thanks for her contributions. Not only has she written an excellent and informative catalogue text but together with S. Peter Stevens, administrator for the Collection of Candida and Rebecca Smith, she spent many hours selecting the works in the exhibition. We also wish to express our appreciation to S. Peter Stevens, without whose efforts the project would not have become a reality.

Throughout the organization of the exhibition we received the full cooperation of the museums participating in the tour, and to the directors and staffs of those institutions, we extend our sincere appreciation.

This publication could not have been produced without the expertise of James H. Witt of The Arts Publisher, to whom we are most grateful. Warm thanks also go to the staff of the International Exhibitions Foundation, notably B.J. Bradley, for editing the catalogue and seeing it through production, and Linda Bell, Lynn Kahler Berg, Deborah Shepherd, Taffy Swandby, and Sarah Tanguy, for attending to the many details involving in organizing and circulating the exhibition.

ANNEMARIE H. POPE
President
International Exhibitions Foundation

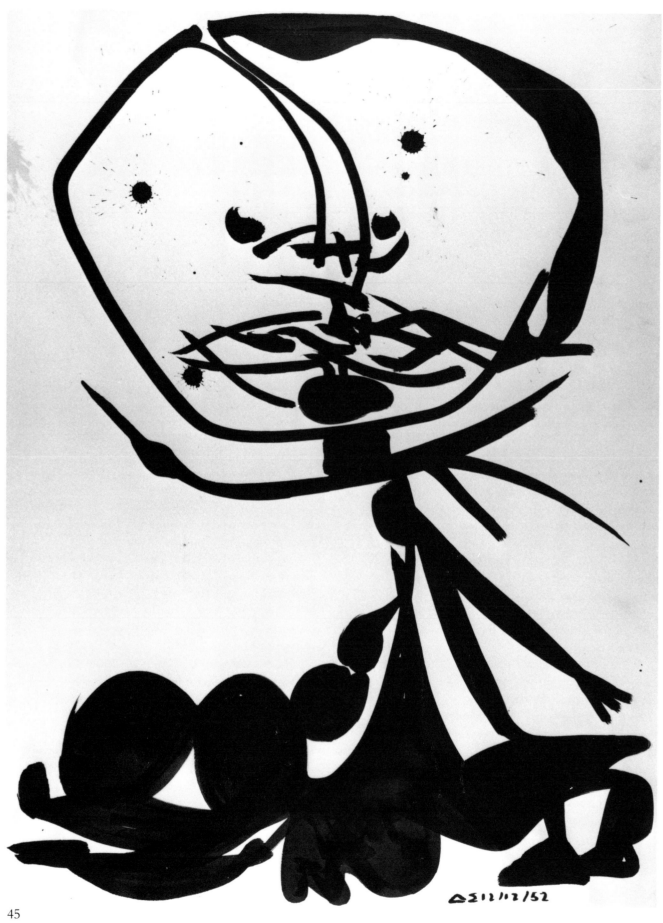

45

AUTHOR'S ACKNOWLEDGMENTS

Because any publication involves a great deal of research, time, effort, and thought, this catalogue would have been impossible to execute had it not been for the generous contributions and support of several people. Jane Boesch, from the library at Phillips Exeter Academy, was extremely helpful in obtaining through interlibrary loan various publications on David Smith that I persistently requested. Also instrumental in supplying me with materials that were unavailable to me here in Exeter were Laura Coyle and Anna Brooke. The staff at the Archives of American Art, Smithsonian Institution, in the Washington, D.C., and Boston offices were very gracious in their efforts at finding certain materials for me. I would also like to thank E. A. Carmean, Jr., Ann Freedman, Garnett McCoy, Deborah Shepherd, and Taffy Swandby for their patience, advice, and general spirit bolstering throughout the genesis of this catalogue. Candida and Rebecca Smith and S. Peter Stevens deserve special thanks for the great interest, support, thoughts, and hospitality that they generously extended from the outset of this project. Finally, I would like to express my gratitude to my husband, H. Nichols B. Clark, for giving me so much of his time, for lending his ears and eyes frequently and patiently each time I needed a sounding board, and especially for having confidence in me. Nick brought fresh insights into the project and helped me to view the drawings of David Smith in a new light.

TRINKETT CLARK

13

70

14

INTRODUCTION

Although David Smith was undoubtedly one of the most prolific and outstanding artists of the twentieth century, only his achievements and contributions to modern sculpture have been seriously considered until recently. In 1979 the Whitney Museum of American Art presented "David Smith: The Drawings," a major show devoted to Smith's works on paper, which traveled to The Detroit Institute of Arts. Organized by Paul Cummings, this exhibition was the first to study Smith's accomplishments as a draftsman and introduced the public to a facet of the artist that had been virtually ignored. Smith did exhibit his drawings frequently, but not many had been on view between his death in 1965 and 1979. Only four or five of the drawings in the current exhibition have been exhibited since Smith's death. It is difficult to determine which specific drawings were actually on view before Smith died as they were usually listed as "Untitled." The Whitney Museum show explored Smith's influences, themes, working technique, and thoughts on drawing. Following this impressive introduction, in 1981 the Edmonton Art Gallery mounted "David Smith, The Formative Years: Sculptures and Drawings from the 1930s and 1940s." Organized by Karen Wilkin, this survey examined Smith's imagery during his early career and the relationship between his sculpture and drawings. As further testament to the burgeoning interest in Smith's compositions on paper, in 1982 Miranda McClintic

assembled "David Smith: Painter, Sculptor, Draftsman" for the Hirshhorn Museum and Sculpture Garden. This exhibition gave an overview of the various media in which Smith worked. Once again, the viewer could perceive the relationship between Smith's drawings and sketches and his sculpture. Finally, in 1983 the Arts Club of Chicago produced "David Smith: Spray Paintings, Drawings, Sculpture," which was a small but inclusive presentation.

Now, the International Exhibitions Foundation has organized the first comprehensive traveling exhibition celebrating Smith's merit as a draftsman. With the tireless assistance and generous cooperation of S. Peter Stevens, administrator for the estate of David Smith, and Candida and Rebecca Smith, I selected eighty-four drawings that illustrate not only the profuse legacy of David Smith's hand but also the force and vitality of his imagination. With the exception of student works from the 1920s, the show includes drawings from every period of Smith's artistic career and surveys every style that he explored. I must emphasize that we have put the drawings under six loose and interrelated umbrellas: the figure, the landscape, sculptural studies, the gestures, the "personages," and the sprays. Since many drawings belong in at least two groups, it is important to remember that these categories should not be construed rigidly but simply as a means of isolating similar subjects, themes, or styles for

visual and intellectual study.

In a lecture on drawing delivered at Tulane University in 1955, Smith stated:

The drawing that comes from the serious hand can be unwieldy, uneducated, unstyled and still be great simply by the superextension of whatever conviction the artist's hand projects and being so strong that it eclipses the standard qualities critically expected. The need, the drive to express can be so strong that the drawing makes its own reason for being.

Drawing is the most direct, closest to the true self, the most natural liberation of man—and if I may guess back to the action of very early man, it may have been the first celebration of man with his secret self—even before song.[1]

Smith went on to discuss the freedom of line and the role drawing had for him as a sculptor:

Simply stated, the line is a personal-choice line. The first stroke demands another in complement, the second may demand the third in opposition, and the approach continues, each stroke more free because confidence is built by effort. If the interest in this line gesture making is sustained, and the freedom of the act developed, realization to almost any answer can be attained. Soon confidence is developed and one of the secrets of drawing felt, and marks come so easily and move so fast that no time is left to think.

Even the drawing made before the performance is often greater, more truthful, more sincere than the formal production later made from it. Such a statement will find more agreement with artists than from connoisseurs. Drawings usually are not pompous enough to be called works of art. They are often too truthful. Their appreciation neglected, drawings remain the life force of the artist.

Especially is this true for the sculptor, who, of necessity, works in media slow to take realization. And where the original creative impetus must be maintained during labor, drawing is the fast-moving search which keeps physical labor in balance.[2]

A man of tremendous energy, Smith's output was prodigious—his habit was to work in his sculpture shop-studio during the day, and at night he would relax and wind down by drawing. He usually worked concurrently on several projects and in several styles, so that his ideas for drawings, paintings, and sculpture were closely intertwined. One must keep this interplay in mind when looking at his work, for he never closed off one avenue of energy or artistic vision while pursuing another. All of his art relates to what was created before and after; all of his art conveys the essence of the man. One can better understand Smith's own attitude from a passage of a lecture given in Portland, Oregon, on 23 March 1953:

I make 300 to 400 large drawings a year, usually with egg yolk and Chinese ink and brushes. These drawings are studies for sculpture, sometimes what sculpture is, sometimes what sculpture can never be. Sometimes they are atmospheres from which sculptural form is unconsciously selected during the labor process of producing form. Then again they may be amorphous floating direct statements in which I am the subject, and the drawing is the act. They are all statements of my identity and come from the constant work stream. I title these drawings with the numerical noting of month day and year. I never intend a day to pass without asserting my identity, my work records my existence.[3]

Before examining the drawings included in the exhibition, it is essential that the reader know more about David Smith. Born in Decatur, Indiana, on 9 March 1906, Smith was the son of a telephone technician-executive and inventor, and a school-teacher. From his father, Smith learned about machinery and explosives, while from his mother, who was a devout Methodist, Smith received a strict religious upbringing. In 1921 the family moved to Paulding, Ohio, where Smith would eventually serve as the official illustrator for the Paulding High School yearbook. Through a cartoon correspondence course sponsored by the Cleveland Art School, Smith's interest in art was kindled, and although he was a mediocre student, his grades in art class were very good.[4] Intending to pursue this field of study, Smith attended Ohio University in Athens for a year (1924–1925) but was disenchanted with the art courses there. The summer of 1925 found Smith working at the

Studebaker Company's factory in South Bend, Indiana, after which he enrolled briefly at Notre Dame University before being transferred by Studebaker's finance department to an affiliate in Washington, D.C., called the Morris Plan Bank. In Washington Smith studied poetry at George Washington University before being reassigned to New York in the fall of 1926. There he found an apartment in the same building as an art student named Dorothy Dehner, whom he would marry in December 1927. Dehner, who was cultured, sophisticated, and urbane, suggested that Smith attend classes at the Art Students League, and soon he enrolled. At the League, Smith first studied painting with Richard Lahey and in 1927 painting and drawing with John Sloan and Kimon Nicolaides, respectively. Smith wrote about this experience in his autobiographical sketch:

from Sloan—got a certain amount of feeling—of knowing the artist's position as a rebel or as one in revolt against status quo—heard about cones and cubes and Cézanne from him.... Shifted around to study with KIMON NICHOLADIES [sic] drawing "feeling for sensitivity in a line."[5]

In 1928 and 1929 he studied with Jan Matulka, a Czech who introduced Smith to the works of Piet Mondrian, Wassily Kandinsky, the Russian Constructivists, and the Cubists, especially Pablo Picasso. Matulka's work, with its heavy lines and flatly patterned compositions, can be briefly characterized as simultaneously analytical and expressive, with a tentatively abstract quality.[6] Smith said of Matulka:

"Great Awakening of Cubism" Matulka was the kind of a teacher that would say—"you got to make abstract art"—got to hear music of Stravinsky—Have you read the "Red and the Black"—"Stendhal" Language was not fluent but he was right for me at that time. Matulka was a guy I'd rather give more credit than anyone else.[7]

In 1929 the Smiths spent several weeks in Bolton Landing, New York, which is on Lake George, at the farm of Thomas and Weber Furlong, friends from the League. At this time the Smiths purchased an eighty-six acre fox farm in Bolton Landing. (In 1940 they would leave New York City to live full-time at Bolton Landing.) Through the Furlongs the Smiths met John Graham, a White Russian emigrant and another influence on Smith. Graham, a painter, provided a constant source of encouragement as well as artistic ideas and trends, particularly on primitive art and the European modern movement. Through periodicals such as *Cahiers d'Art* and *Transition*, he introduced Smith to the sculpture of Picasso, Pablo Gargallo, and Julio González, who were all working with iron. Graham was often asked to serve as a consultant for private collectors. Through Graham, Smith was commissioned in 1934 to construct bases for the African sculpture collection of Frank Crowninshield, the editor of *Vanity Fair*. And because of Graham, the Smiths soon were part of a circle of New York artists that included Milton Avery, Stuart Davis, Arshile Gorky, Adolph Gottlieb, Edgar Levy, and Jean Xceron.

Smith became aware of the tenets of European modernism through exhibitions held in New York at The Museum of Modern Art, Brummer Gallery, Julien Levy Gallery, and Pierre Matisse Gallery among others. Through the efforts of Alfred Barr, the Modern mounted "Cubism and Abstract Art," which Smith missed, and "Fantastic Art, Dada, Surrealism" in 1936–1937, and in 1939–1940 "Picasso, 40 Years of His Art" was on view. The work of Joan Miró, Alberto Giacometti, Paul Klee, and Picasso would now play a role in Smith's development.

Throughout the 1930s and 1940s Smith supported Dehner and himself with a series of jobs. Dehner also had a small inheritance upon which they could rely that enabled them in October 1931 to go to the Virgin Islands, where they remained until June 1932. While in St. Thomas, Smith executed some drawings and paintings characterized by undulating lines of various widths that outline overlapping contours of color or

linear patterns (see No. 11, 12, and 43). These maplike configurations marked the emergence of Smith's own style. Edward Fry writes that this trip "clarified Smith's previously tentative efforts to translate European modernism into the vernacular of American experience; it also marked a first loosening of the bonds imposed upon Smith by his own Calvinist, Anglo-American, and positivist heritage."[8]

Smith constructed his first sculptures during this sojourn, making them out of coral. Of this artistic shift, he later said:

After my student period in painting finishing with the abstract painter Jan Matulka, my painting had turned to Constructions which had risen from the canvas so high that a base was required where the canvas should be, I now was a sculptor.[9]

By the end of 1932, Smith had constructed sixteen sculptures, using wire, shells, coral, pieces of wood, and lead.[10] Partially influenced by his experience in the Studebaker factory and by the sculpture seen in *Cahiers d'Art*, Smith began to use steel. He was to discuss the use of materials in a lecture given in March 1953 in Portland, Oregon.

I work in most media, but my especial material is steel, that which has been longest in my experience, and which seems to me unique in sculptural media. The metal possesses little art history. Its associations are primarily of this century, it is structure, movement, progress, suspension, cantilever and at times destruction and brutality. Its method of unity need not be evident. Yet its forms of geometry, planes, hard lines are all constant with the [sic] that of my time. Altho material is always subservient to concept certain properties of this material are unique and have not existed before this century.[11]

By 1933 Smith was welding sculpture in a foundry in Brooklyn, New York, called Terminal Iron Works, which served as his "studio" until spring 1940 when electricity became available in Bolton Landing. His farm became known as Terminal Iron Works at that time.

Yet Smith never abandoned drawing or painting and stated in an interview with David Sylvester in 1961:

I belong with painters, in a sense; and all my early friends were painters because we all studied together. And I never conceived of myself as anything other than a painter because my work came right through the raised surface, and color and objects applied to the surface. Some of the greatest contributions to sculpture of the 20th century are by painters. Had it not been for painters, sculpture would be in a very sorry position.

Some of the greatest departures in the concept of sculpture have been made by Picasso and Matisse.... Painting and sculpture aren't very far apart....

I painted for some years. I've never given it up; I always—even if I'm having trouble with a sculpture I always paint my troubles out.[12]

Smith's artistic horizons were broadened when he and Dehner traveled to Europe in the fall of 1935, where they visited Paris, Greece, London, and the Soviet Union. Graham met them in Paris, introducing them to artists, private collectors, and various museums. Smith had already begun carrying a small notebook with him in which he made notes and small drawings.[13] He filled his notebooks from this trip with information about works of art he had seen—often with illustrations—as well as comments about the condition of certain works and technical remarks about both painting and metal-working techniques.[14] Smith was especially fascinated with the imagery of Breughel and Bosch, calling it "surrealist."[15] What particularly impressed him were issues of technical facility; in this regard he realized how crucial good drawing was, noting in his diary:

When I saw a show of five hundred drawings by Dutch and Flemish artists at the Orangerie in Paris in 1935, I realized what an inadequate draftsman I was. That is why drawings have been a large part of my work time ever since.[16]

Returning to America in July 1936, he began to explore and struggle with some of these newly assimilated thoughts. His work now was a union of

Cubism, Constructivism, Surrealism, and his own intense vision. Hilton Kramer later wrote of this chapter of Smith's oeuvre:

In effect, he restored the Constructivist idea to the Cubist tradition, which had spawned it in the first place, and then threw in the Surrealism of his own generation for good measure. Once this synthesis was achieved, Smith moved freely in and out of figurative and nonfigurative modes; heads, figures, landscapes, animal images, mythical and Surrealist fantasies, the symbolic anecdote and the purely formalistic conception were all available to his medium.[17]

Slowly Smith's style became more assertive. His work from this period shares certain characteristics with the European avant-garde, but Smith's own identity was gradually emerging and prevailing. His imagery began to betray some of his innermost fears—rejection and impotence. Smith had ambivalent feelings toward women, which he repeatedly expressed through the image of the violated female figure. Sexual elements, often quite graphic and savage, regularly appeared in his work, especially the drawings of the 1930s and 1940s. He compulsively clipped from magazines photographs of women in various suggestive poses, dancers, musicians, billiard players, and insects and animals. After pasting these images into his sketchbook, Smith would often draw or paint breasts, cannons, or other phallic imagery onto the figure. He frequently created improbable subjects—the human skeleton or flying fish skeletons or falling birds, all with an aloofness yet with technical facility. In these outlandish creations, Rosalind Krauss astutely recognized Smith's conflicting emotions regarding tradition, writing:

But with a primitive part of his being he also responded to something that was inherent in the very art he was bent on rejecting. Smith was thus simultaneously repelled by and attracted to the Surrealist drama of desire, possession, and violation being staged by the European sculpture of the mid-thirties.[18]

In the late 1930s, inspired by Sumerian seals and Greek coins he had seen while abroad, and needing an outlet for his outrage with war, society, and women, Smith began to direct his aggressive energies toward a surrealist series of antiwar medallions, the *Medals for Dishonor* (see No. 23). While executing these pieces, Smith received a welcome source of attention late in 1937: Marian Willard expressed interest in his work, offering him his first solo exhibition, which took place in early 1938 at her East River Gallery. Willard represented Smith for the next eighteen years, exhibiting the completed *Medals* in 1940, and often provided financial and moral support by recommending him for teaching positions and lectures and by promoting him to interested collectors. These jobs forced Smith to speak about his art, and he proved to be quite articulate on the subject.[19]

Smith's productivity during the war years was sharply curtailed both because of his lack of materials and because of his involvement with the war effort. He worked from 1942 until 1944 welding tanks at the American Locomotive Company in Schenectady, New York—usually from midnight to eight o'clock in the morning. However, he did continue to draw (mostly ideas for sculpture) and make sculpture when time, energy, and materials allowed. By late 1944 Smith was once again busy at Bolton Landing, working on his art in full force, exhibiting frequently, and gaining recognition and support from the critics. His work now began to take on a more expressive, abstract quality, reflecting not only the transition occurring generally within the avant-garde at that time but also his own physical isolation from the mainstream.

Smith's solitude was emphasized even more when he and Dorothy Dehner separated in 1950 (the divorce was made final in 1952), and Smith, alone at Bolton Landing, began to work with a furious intensity. He would make occasional forays each year to New York, where he would view exhibitions and visit friends. But his self-imposed exile led to a style completely his own—in both his two-dimensional works and his sculpture. The act of creation soon became as important and

crucial to Smith as the final result. In 1950 he was awarded a fellowship from the Guggenheim Foundation that was renewed in 1951. Because of this grant Smith had the funds to buy an abundance of materials. With some of the Guggenheim funds, Smith purchased reams of linen rag paper of all sizes—the quality of his material was of first priority. Smith wrote: "My drawings are made either in work books or on large sheets of linen rag. I stock bundles of several types, forgetting the cost so I can be free with it."[20] His confidence also grew, and he began making more sculptures and drawings than ever before. The grant served as a catalyst for his inventive energies; both his sculpture and two-dimensional works underwent changes. His earlier drawings had always had a tinge of aggression or violence to them, but this force had been awkwardly contained. The works executed after 1950 emanate a freeness of gesture, projecting spontaneity, vitality, self-expression, and even joy. The aggression was virtually released through the act and pleasure of creation. It is these qualities that link Smith tentatively to the artists of the New York School, although Smith did not feel he belonged to any specific group and fought against being categorized. Identity was crucial to Smith, and the automatism of the Surrealists seems to have held an appeal in this regard. Writing in the early 1950s, Smith said of the artist and the act of creating:

Yet lonesomeness is a state in which the creative artist must dwell much of the time. The truly creative artist is projecting towards what he has not seen, and can only take the company of his identity. The adventure is alone and the process itself becomes actuality. It is him and the work. He has left the subject behind.[21]

In addition, Smith had an impressive collection of books in his library, indicating an eclectic interest in the many cultures and art of the world. Judging from his library, his writings, and his drawings of the 1950s, Smith was intrigued with the art of the Far East. Thus the calligraphic, flowing brush of the Orient began to emerge in

Smith's drawings, becoming an intrinsic aspect of his visual language. In a symposium at The Museum of Modern Art in 1952, Smith said:

A Chinese painter explained that although the long blade leaves of an orchid droop toward the earth, they all long to point to the sky. This Chinese attitude of cloud-longing is an eye through which I view form in works of celebration and, conversely, in those of a specter nature.

Certain Japanese formalities seem close to me, such as the beginning of a stroke outside the paper continuing through the drawing space to project beyond, so that the included part possesses both the power of origin and projection. This produces the impression of strength, and if drops fall they become attributes or relationships. Similarly, if the brush flows dry into hair marks, such may be greater in energy, having at least a natural quality not to be reworked, being sufficient in intent to convey the stronger content. It is not Japanese painting but some of the principles involved that have meaning to me. Another Japanese concept demands that when representing an object suggesting strength—like rocks, talons, claws, tree branches—the moment the brush is applied the sentiment of strength must be invoked and felt through the artist's system, and so transmitted into the object painted.[22]

Smith began, at this time, to experiment with his media, adding egg yolk to his ink, which gave his works a fluidity and richly lustrous texture. Cummings spoke aptly of this process:

Black ink and egg yolk combined to a viscosity that flowed with greater ease than the oil and brush or even the pen he [Smith] had so rarely employed. The various brushes he used insinuated their individual qualities, either in the luxuriant flowing mutable strokes of the soft sable or in the roughly textured surfaces evidenced by a less yielding pig-bristle brush.[23]

The calligraphic drawings done by Smith are his most gestural and expressive, each stroke vigorously applied without any forethought or structure.

Smith's personal life changed significantly when he married Jean Freas in 1953. Although the marriage ended in 1961, the couple had two daughters, Rebecca and Candida, who brought great joy and pride to their father. In a letter to Helen Frankenthaler, Smith said:

I look and look at my daughters painting. If I'm really influenced at this stage it will be by them. Such abandon. Such unpremeditated unknowing unthinking rare action. Abandoned and owing no part of their mind to anyone. And such a pure kind of feeling, and personal emotion.[24]

These words could almost describe Smith's drawings from the late 1950s and 1960s. Smith had successfully broken free of art historical associations and constraints through his drawings, which truly express and reveal the exuberant emotions of his inner spirit. Even the sprayed drawings, done from 1958 until his death, indicate the underlying tension and vitality of Smith's vision. In a draft for a speech he gave at the Woodstock Conference of Artists in 1952, Smith described his own artistic quest:

In the actual sense we should not stretch to invent but we should feel what has gone before us, and know what has been found, and what has been found is heritage and what are problems are the things we are to find, the seeing of things from our own vantage point, which is a place no artist has stood before and our work will be what no one has seen before and not that of invention in the narrow sense, but passionately found visions because they are inspired answers to the problems of who we are in the time we were placed to speak.[25]

By the early 1960s Smith's audience was international, and he had even begun to enjoy some financial rewards. In 1961 Smith was interviewed by David Sylvester for the BBC. In 1962 Smith was one of a group of sculptors invited to take part in the internationally renown Spoleto Festival of Two Worlds, where he produced an incredible twenty-seven sculptures in thirty days. In February 1965 President Lyndon Johnson appointed Smith to the National Council on the Arts. Tragically, however, on 23 May 1965, at the pinnacle of success and only fifty-nine years old, David Smith died following a truck accident near Bennington, Vermont. Smith left behind an extraordinary legacy of almost 700 sculptures, as well as numerous paintings and drawings—in effect, a procession recording his life and imagination through the fertile imagery of his visual vocabulary.

Smith's drawings convey an energy, a virtuosity, an individuality, and even, at times, an element of humor. They display a relentless exploration of line, color, and composition, as well as of the memory and the imagination. They vary from being meticulously descriptive and analytically rendered to spontaneously fluid and painterly. Sometimes the results are lyrical and elegantly expressive; often the drawings are raw, almost brutal in their challenge and impact. But always, the drawings are sensitive assertions of Smith's being. At a talk given at Ohio University in Athens on 17 April 1959, Smith said:

Art is made from dreams and visions and things not known and least of all from things that can be said. It comes from the inside of who you are, when you free yourself. It is an inner declaration of purpose, it is a factor which determines artist identity.[26]

Like his other work, Smith's drawings exude the spirit of an inexhaustible vision struggling for expression—and for release.

Throughout his career, Smith never lost his keen interest in portraying the figure. In all of its various postures—standing, reclining, striding, dancing—the figure appears regularly in each medium and in each style that he undertook. Smith's figures are rendered both realistically and abstractly; some are academically proficient, whereas others reflect the spontaneous freedom that was so vital to Smith and his art. Figural imagery abounds in Smith's many sketchbooks; filling page after page with figures, Smith would work and rework the human form, often in a surrealistic fashion, often abstractly.

The figural drawings selected for this exhibition show Smith's sensitivity of line and form, as well as the variety of styles in which he worked, to give the reader an understanding of his development as a draftsman as it relates to the rest of his oeuvre.

The first figure in the exhibition, *Untitled* (No. 1), is one of Smith's studio nudes of circa 1930. The drawing was torn from a sketchbook, and its rather

muscular, blocky form shows the influence of Matulka, without having the awkward, stylized quality of Matulka's drawings. Realistic shading and depth are indicated by flat patches of black and shapeless areas of hatched and cross-hatched lines, yet these same areas of black and line seem to be arbitrarily placed at times, giving the figure an inaccessible quality. Her face is featureless, and the areas around her left arm and right breast are ambiguously delineated. This awkwardly defined woman shows that Smith's interest in Cubism was just emerging.

By 1934 Smith had temporarily set realism aside and was working in a manner that referred to Surrealism and Picasso. No. 2 and 3 show elastic, curvilinear figures. No. 2 depicts two headless nudes holding hands, while No. 3 is a single reclining nude with neck arched and head poised toward the sky. Both of these drawings employ hatched and cross-hatched lines that have no relation to shade or depth as in the earliest drawing. The effect of these lines is also different than that of No. 1. Rather than reflecting the rough, heavy style of Matulka, these patches of lines serve to emphasize the fluidity and weightlessness of the figures' outlines. Smith plays tricks with his figures in these two drawings. The right arm of the left figure in No. 2 is made from negative space, which Smith fuses to the rest of the body; in No. 3 the head is amorphous, while the left breast is set within the torso. All these elements, when combined with the acrobatic stances of the figures, bring to mind the biomorphic imagery of Miró and Picasso during the latter's years at Boisgeloup, France, in the early 1930s.

In a drawing from 1937 (No. 4), Smith returned to the classical standing nude, leaning on a pedestal, which shows he understood the structure and form of the subject. Working in pastels, the artist executed this drawing in an accomplished academic fashion, and thus it is not something that would be immediately associated with Smith. However, it does demonstrate his technical facility and displays the versatility of styles seen throughout his career.

In the following year Smith produced a drawing (No. 5) that has great significance in relation to his sculpture. Barbara Morgan, a photographer very much involved with American dance, wanted to capture the revolutionary movements of Martha Graham so there would be a record of Graham's contribution to the dance world. In 1936 Morgan began to photograph Graham, preserving on film the emotional essence of Graham's choreography in some very beautiful and dramatic photographs (see fig. 1). They were exhibited in New York, reproduced in a periodical in the 1930s, and finally assembled into a book entitled *Martha Graham: Sixteen Dances in Photographs*, which was published in 1941. Smith was very taken with these photographs, and in 1938 he executed a sheet that was a composite of six of Morgan's images of Graham from the dances *Lamentation* and *Frontier* (the top right image of No. 5 is from *Frontier*). Smith's drawings must have been hastily done judging from the pencil strokes and rough brush-work. Yet these six sketches convey the energy and emotion seen in Morgan's photos, as well as the force and movement of Graham's dances. The image of Graham, with her tubular veil, in the various stages of grief in *Lamentation* is a visual motif upon which Smith expanded in his later drawings and sculpture.[1] In addition, Smith also used the arabesque in his work, and many of his works are filled with dance imagery,[2] as in No. 6.

This "ballet à deux" is done in oil on paper. A female dancer, performing an arabesque, and a supporting male dancer are depicted in an angular yet fleshy fashion. This drawing suggests both Cubist and African influences. As noted earlier, Smith was certainly aware of primitive and African art. The brown and black shades of the two dancers work harmoniously with the subtle blue and flesh tones of the base and background and also reveal Smith's growing awareness of color. This theme of a male and female dancer would appear often in Smith's work.

Although Smith continued to draw during the

1940s, these efforts were largely related to sculpture. By the early 1950s, Smith was expressing himself more directly and freely—his line is bolder and his figures emanate both confidence and spontaneity. These qualities are clearly evident in $\Delta\Sigma$ *1/14–52* (No. 7). This huge, gestural figure in salmon and pink, with heavy black outlines, sits on a small stool and holds what might be a brush. The sticklike arms and small head contrast sharply with the proportions of the breast and massive, shapeless torso. No doubt executed hastily, as evidenced by the dripping colors, this drawing has an aggressive feeling, which is emphasized by the violent black strokes. Although gestural, an element of control is obvious when compared with $\Delta\Sigma$ *1/6/55 M. NY* ③ (No. 8).

No. 8, a beautiful gestural scene done in 1955, is far more abstract. The violence of the previous drawing has quieted, and fluid, curving brown strokes outline two reclining nudes. The tranquility of this drawing is reinforced by the flat pink strokes arbitrarily placed among the outlines. Unlike Smith's earlier figural drawings, this one is quite seductive in its lush, abstract brushwork and subtle coloring.

In the last few years of his life, Smith returned to a realistic rendering of the figure, making a series of nudes on paper and on canvas in black egg ink. His nudes of this period, illustrated by No. 9, *David Smith DO 5–1963*, and 10, *David S. / DO 13 / 1963*, from the Dort series, are flowing curvilinear forms, realistically portrayed. Both of these drawings have a spontaneity and freeness to them, but Smith replaced the aggressive quality seen earlier with a sense of abstraction and remoteness. In *David Smith DO 5–1963*, the two figures seem to be poured on to the paper, showing that he had not forgotten Pollock's technique. The figures are more controlled, however, than is the nude in *David S. / DO 13 / 1963*. Here, we see a loosely painted, warm, sensuous nude, as lush in its own way as a Rubens.

In contrast to these two fluidly drawn compositions, Smith simultaneously was rendering the figure abstractly, as in No. 42. Although this sprayed drawing, *1 $\Delta\Sigma$ 3–16–63* (study for "Cubi VI"), technically falls under the category of studies for sculpture, it is certainly figural in conception. Our eye is immediately drawn to the diamond-shaped torso, under which two rectangular legs are poised in midstep. The upward motion of the head and arms lend the figure a verticality and balance, as well as emphasize the kinetic force contained within. Clement Greenberg wrote of the sculpture *Cubi VI* in a special issue of *Art in America* devoted to Smith in 1966, and the following passage applies to the accompanying study as well:

No matter what, Smith returned periodically to the scheme—not so much the forms or contours—of the human figure as though to a base of operations. His art used to be filled with schematic allusions to many other things in the visible world: landscape, houses, furniture, animals—especially birds—and even plants. But as he turned increasingly abstract in latter years, in conception and scheme, not to mention execution, the human figure became more and more the one constant attaching him to nature. It was the soar of the human figure that held him, the uncompromising upward thrust it makes, the fight it carries on with the force of gravity.[3]

Always a part of Smith's working stream, the figure in all of its manifestations reflects Smith's tireless struggle with a classic subject—from the bulky, massive forms of the early years, he fought with the figure and finally met the challenge with his abstractions and graceful nudes of the 1960s.

Smith's environment was always important to him, and he often referred to it in his art. He was attracted to both the city and the country for the activity and tranquility that each represented. Discussing his relationship to the world around him in his notes for Elaine de Kooning's article "David Smith Makes a Sculpture," which was published in *ARTnews* (September 1951), Smith observed:

The ironworks in Brooklyn was surrounded by all night activity—ships loading, barges refueling, ferries tied up at the dock. It was awake 24 hours a day, harbor activity in front, truck transports on Furman St. behind. In contrast

the mountains are quiet except for occasional animal noises. Sometimes Streevers' hounds run foxes all night and I can hear them baying as I close up shop. Rarely does a car pass at night, there is no habitation between our road and the Schroon River 4 miles cross country. I enjoy the phenomenon of nature, the sounds, the Northern Lights, stars, animal calls, as I did the harbor lights, tugboat whistles, buoy clanks, the yelling of men on barges around the T.I.W. in Brooklyn. I sit up here and dream of the city as I used to dream of the mountains when I sat on the dock in Brooklyn.[1]

Smith depicted the landscape-cityscape throughout his career; his scenes had an abstract quality from the beginning and often were loosely and hastily composed. His trip to St. Thomas in 1932 resulted in a series of drawings similar in their use of meandering lines and planar patterns (see No. 11, 12, and 43). In a discussion of Smith's early working method Cummings noted:

He selected one of the drawings, made photostats, and reworked this basic pattern by adding lines and areas of various colors. This was the beginning of a procedure of variations on a theme that he would continue to follow, often producing as many as a dozen or more drawings a day.[2]

The two drawings included here simultaneously hint at and move away from the influence of Matulka and Davis. Verging on the gestural, the overlapping planes and sinuously moving lines suggest a freedom and spontaneity not felt in the work of Smith's colleagues. The perspective in these Virgin Islands landscapes is aerial, with water, shoreline, and mountains converging in sensuous, flowing skeins that compress the space within their boundaries. Smith invariably viewed landscapes from an aerial point of view, later commenting:

Today the landscape may be viewed on a cross country journey from a plane three miles up. Looking down there is no space. The solid earth, its rocks and hills become an endless flat plane. Houses, factories, hard objects, solids become only pattern. Rivers, highways, man-made boundaries are flowing graceful sweeping lines opposed by spots of lakes and squares of fields. The view from space makes solid form appear pattern.[3]

In both maplike landscapes, the image of the shell

is suggested, and rock forms and a fish are evident in No. 12, where the four red boxes floating on the left are a curious and incongruous addition to this otherwise fluid landscape. The linear, animated patterns of these two drawings prefigure Smith's iron *Aerial Construction,* 1936 (K43, Hirshhorn Museum and Sculpture Garden), as well as a later sculpture, *Hudson River Landscape,* 1951 (K257, Whitney Museum of American Art; see fig. 2).[4]

By 1951 Smith had freed himself from outside sources and was concentrating solely on expressing himself through the brush, which the hilly snowscape of No. 13 shows. Grayish blue shadows enhance the gentle purple strokes, illustrating Smith's arbitrary use of color. This landscape is interesting for its drips, its lilting quality of line, and its indication of spaces through the empty white areas.

No. 14 (see color plate 1) of 1952 is a stunning cityscape whose network of black lines borders areas of cerulean blue. Almost Marin-esque in its jagged intersecting diagonals, horizontals, and verticals, this view is framed on the top with clouds and on the bottom with water (the Hudson River?). The curving lines contrast effectively with the geometric strokes of the buildings and ship masts in between. The heavy black "V" shape on the right almost serves as a pedestal, similar to those used in some of Smith's studies for sculpture.

Another cityscape, also from 1952 (No. 15), is not as elegantly executed because the artist used rougher forms in brown and yellow. The tiny city in the lower left rests beneath a huge yellow sun, while on the right, an oval shape (a head?) with a horn floats above a huge, menacing brown mass, giving the drawing the ominous quality of an impending storm.

No. 16 (1955) and 18 (1957) are similar to No. 15 in their rough, expressionistic, and hastily rendered brushwork, yet these two drawings are more refined. The staccato strokes of No. 16 depict a landscape with clouds; there is no element of depth—something Smith continually denied in his brush. Each stroke seems to float on top of another, receding and projecting simultaneously. The only sprinkle of

I have hundreds of sculptures on paper which time and conceptual change, have passed by.[1]

color is the ochre smear in the upper left corner where Smith signed his name. In contrast, No. 18, another mountainscape expressively executed, is a visual feast in vivid reds, blues, and gold.[5] Even in this drawing, the sense of space is compressed.

Drawn while Smith was visiting Helen Frankenthaler and Robert Motherwell in Provincetown, Massachusetts, in 1956, No. 17 is one of the richest and most beautiful of Smith's abstract drawings. A seascape, this gestural drawing illustrates Smith's powerful brushwork, with its lush, velvety texture. Of his visit to the Motherwells, Smith wrote:

Had fine time in Provincetown—we all did made [sic] 15 good egg drawings—a bit better in ways than before. It takes so much and I feel so feeble to what I can see possible but I cannot get there without traveling the faltering long road. Cannot skip the distance and arrive at the goal. But each step feels better than the last and stronger—but so far to go—that too in sculpture.[6]

No. 19, a sprayed landscape from 1960, is also gestural in character. Smith often highlighted the unsprayed white areas with paint, giving them a personal quality that, because of the mechanical technique, the other sprays lacked. In this spray, the rough, darting ivory brushstrokes define mountains and clouds floating in a dark, dense space. This landscape reflects the rhythms, shapes, and colors of the constantly changing seasons to which Smith was so sensitively attuned.

When Smith was invited to participate in the Spoleto Festival, he worked in an abandoned factory in Voltri, several kilometers west of Genoa in the hills along the Mediterranean coast. Besides executing twenty-seven sculptures, Smith made a series of drawings. No. 20, number nine from the series, is a hastily drawn landscape, with long bold brushstrokes and a broader, less confined sense of space that reflects the Italian hillside.

All of these drawings are bound together by their loose conception of space, their impressionistic line, and the abstract, gestural sense that prevails. Thus they stand as an eloquent testament to the union of the artist with his environment.

Smith's creative flow was never hindered when he switched from one medium to another. In fact, the constant exchange between pen, brush, and welding torch seemed to enhance his artistic vision. Writing about the dichotomy between drawing or painting and making sculpture, he observed:

I do not recognize the limits where painting ends and sculpture begins.... There is a difference in degree in actual space and the absolute difference in gravity.[2]

Not yielding to the constraints of his medium, Smith also never worked in a consistent or traditional sequence when he created a sculpture—this is important to remember when looking at the sculptural studies. He made studies for sculptures never begun, studies for actual sculptures, and studies made after completed sculptures. In assessing the role of these drawings for his working technique, Smith wrote:

I follow no set procedure in starting a sculpture. Some works start out as chalk drawings on the cement floor with cut steel forms working into the drawings. When it reaches the stage that the structure can become united, it is welded into position upright. Then the added dimension requires different considerations over the more or less profile form of the floor drawing assembly.

Sometimes I make a lot of drawings using possibly one relationship in each drawing which will add up in the final work. Sometimes sculptures just start with no drawing at all.[3]

The price of materials often restricted Smith. He would make drawings of sculptures that would never be fabricated, while at other times he created an image years before the related sculpture would actually be executed. Sometimes, the drawings for a sculpture were simply starting points from which he would veer during the final production.

Increasingly frustrated by the widening gap between his artistic conceptions and actual output, Smith focused on this dilemma in a letter to Edgar Levy in 1945:

I am bound by a personal outlook, which for me gets solved by work—which I fight to do. I have a dilatory

tendency—there is so much to be read—so many women to lay—so much liquor to drink—fish to catch etc.—but I get the most satisfaction out of my work but I got to have enough of "that there"—the more I work the more it flows (the concept) sometimes while I'm working on one piece I get a conception for a wholly new and different one—on the last two pieces—I've quickly drawn a new one, different, but suggested in a thot [sic] process somehow which took place during the manual work on the other.

I would say that my product is always about a years work behind my conceptions, in number. Right now I have drawings and thinkings for a years labor.

My method may have its faults. From this flowing groove one may hit off a few not as high in quality—as if one were able to preview the result from a vantage point.... My ego flourishes on the quantity of this stream plan—and my mind rolls better when I am deep in it. One gets subject to the emotional fears in this process, like poverty forcing one to give the work up for a while—death, the years are numbered—and they certainly won't last long enough to do what I have planned. I feel I have only started.[4]

Understandably, Smith's studies for sculpture are among the most fertile in their imaginative scope and execution. No. 21 (see color plate 2) belies the influence of Picasso and Arshile Gorky in its bold outlines and flat planes of bright colors.[5] Smith's drawing is not completely abstract as two figures can be distinguished. Although not a study for a specific sculpture, this drawing reflects the ideas and style of some of the sculpture that Smith produced in the mid- to late 1930s, with two-dimensional shapes and lines of steel.

Also responding to European trends, No. 22, *Untitled* (study for "Construction with Points")—the sculpture (K75, location unknown) was executed before 1938—is a surreal composition depicting a precariously balanced figure. Rendered in subtle shades of gray pastels, this figure has exaggeratedly pointed breasts, genitalia, and finlike legs that are suspended in air. This drawing shows Smith's awareness of Giacometti (especially *Woman with Her Throat Cut*, 1932, The Museum of Modern Art), Jean Arp, and Max Ernst.

In the late 1930s while working on his social protest, the *Medals for Dishonor*, Smith made numerous sketches of the many images that he used in the final bronzes. No. 23, one of several studies for the medal entitled "Munition Makers," was executed with precision, facile energy, and a sense of improvisation. As are all the drawings for this series, this one is somewhat macabre, depicting fantastic skeletal figures, naked mangled corpses, and the ominous death symbol, the tank. Smith wrote about each of the images in the medals for the Willard Gallery's exhibition in 1940. Of the "Munition Makers" he said:

Patched skeletons take up their old duties—the shell-bearer, the spearman, the shepherd, the cripple.

The banner of death dollars flys [sic] from the stub of a mediaeval soldier's arm. An ancient coin is held aloft—the "pen is mightier than the sword" but the soldier still clings to the tommy gun.

The antediluvian land tortoise comes forward with low-hanging buttocks. From the imprint of past ages emerge shellholes and ancient coins marked by the gain of the merchants of death.[6]

The implied horrors of the Medals studies are relieved in No. 24, a pastel of an angular, surrealistic figure arrested in an arabesque. This drawing relates to Barbara Morgan's photographs of Martha Graham, particularly her famous pose from the dance *Frontier*. Generating the energy and sense of movement seen in No. 5, the figure is graceful and fluid despite the many-sided, almost blocky form. This drawing is similar to *Dancer A*, 1939 (K115, location unknown). Both No. 25 and 26 employ the Graham motif of sinuous forms struggling beneath a veil-like material. No. 25 is a quick, awkward sketch never realized in three dimensions. No. 26 shows several studies for *Woman Music*, 1944 (K163, private collection), and its fluidly rendered forms relate to Constantin Brancusi and Picasso (see the cubist figure in the lower right). Smith was fascinated by photographs of musicians and often cut out images of women playing harps and glued them into his sketchbooks. In No. 26 the strings of the harp

become the woman's hair, gracefully curving around her undulating figure.

In its linear qualities, No. 27, *David Smith 1946* (study for "Personage from Stove City") (see color plate 3), is similar to *Woman Music 1944 / Woman Music / David Smith 1944* (study for "Woman Music"). Depicting a reclining figure, Smith emphasized color in both the drawing and the finished sculpture from 1946 (K207, Collection of Candida and Rebecca Smith; see fig. 3). This is a whimsical work, not only because of its vivid hues but also in the fanciful use of elements such as the fork tines and stove parts, showing the importance Smith gave to found objects in his work.

By 1946 Smith was beginning to use a stemlike pedestal both in his drawings relating to sculpture and in the completed works in steel (see No. 28, 29, 30, 31, 32, 35, 38, and 39). The figures, which soar into space from a central column, are generally balanced by arclike configurations and show the progression of Smith's development as they become looser and more expressive. No. 28, a composite of five sculptural ideas, shows organic, but awkward, forms of varied sizes and colors floating on a persimmon background. By 1951 the drawings attained an elegant linearity and confidence (see No. 29, 30, 31, and 32). None of these works relates to a specific sculpture, but some suggest certain works that he fabricated around this time. Smith was drawing for the sheer pleasure of the act, making these studies as much for himself as for sculptural inspiration. All of them are gestural in approach and use color in an arbitrary, joyous way.

No. 33, $\Delta\Sigma$ *9/4/52* (study for "Tanktotems"), has two rows of studies related to the sculptural series of Tanktotems that Smith executed between 1952 and 1960 (see K282, K283, K303, K304, K384, K435, K494, K495, K496, and K497). Most of the figures have spindly tripods for legs and at least one boiler tank to indicate heads or torsos. No. 34, also a study for the Tanktotem series, shows only four forms, but they are more finished than those in No. 33. Significantly, Smith glued a piece of paper on top of one of the images, thereby

making a collage. This addition gives the work a found-object quality that relates it more closely to the concept of the sculptures.

No. 35 is a big, expressively rendered sculptural study, relating to *Walking Dida*, 1959 (K477, private collection). This powerful drawing refers to the personages that Smith was making concurrently; it is simultaneously remote, rigid, and gestural. Similar in its almost aggressive force is No. 37, which is beautiful in its use of blues and browns, as well as in its angular jutting forms.

No. 36 is a valuable illustration of the development of Smith's imagery, particularly in regard to his sculpture. The two rows of standing geometric forms range from almost figural to highly abstract, and the images prefigure the Zigs and the Cubis by several years. (The Zig series was begun in 1961, while the Cubis first appeared in 1963.) The jagged white lines in the top three studies at the left probably refer to the effect of light on stainless steel, a material that Smith was just beginning to explore. This drawing gives us some insight into Smith's sculptural vision. Subsequently, some of the motifs in these studies would appear in his sculpture, although none was fabricated exactly as depicted here.

The crisply defined elements of No. 36 contrast with No. 38, whose energetically drawn shapes are arbitrarily placed against a multicolored background. Here Smith examines two types of sculpture: one with splintered lines that strive for release from the pedestals; the other contained within circles or arcs. The top two forms refer to earlier sculptures, *Birthday*, 1954 (K321, private collection), and *Raven II*, 1955 (K346, Collection of Candida and Rebecca Smith), and prefigure *Bouquet of Concaves*, 1959 (K463, private collection); the round images below relate to *Timeless Clock*, 1957 (K436, private collection), *Parrot's Circle*, 1958 (K448, location unknown), and *Agricola XXI*, 1959 (K454, private collection).

The last three works in this series, No. 40, 41, and 42, are all sprayed drawings. No. 40 and 42

THE GESTURE

I've made it because it comes closer to saying who I am than any other method I could use.[1]

are both studies for sculptures: *Windtotem*, 1962 (K555, Collection of Candida and Rebecca Smith), and *Cubi VI*, 1963 (K654, National Museum, Jerusalem), respectively. These sculptures, with their geometric elements, were fabricated in stainless steel. In both of the drawings Smith painted into the negative areas that delineate the sculptures, perhaps trying to evoke the effect of light reflecting from the stainless steel. The gestural painted areas contrast with and enhance the crisply defined forms. No. 41, which is sculptural as well, was never realized in steel. Judging from the outlined form with its indentations, this drawing was presumably made from some kind of tool. The balance of the leaning shape counteracts and mirrors the tension of the upstretched element and adds a delicate touch to the blocky form.

All these drawings are related to the total stream of Smith's productivity; they allude to three-dimensional works as much as they refer to other works on paper. Spontaneously and expressively rendered, they represent the continual interchange between Smith's sculpture and his drawings.

Smith's artistic career was a continuous quest for self-expression; he explored as many outlets as possible in order to assert the strengths and vitality within himself. The artistic gesture, with its boundless freedom, was an avenue through which Smith found release for the struggling tensions in his soul. A mixture of line—governed by energy and emotion—and a painterly application of color, Smith's gestural drawings are the tangible expressions of his innermost spirit. As early as 1932–1933 while in the Virgin Islands, Smith began to draw in a gestural fashion, employing freedom of line, shape, and color (see No. 43). By the early 1950s these characteristics became the dominant features of his work in all media, and a strong personal visual language emerged. Not only a synthesis of many influences but also an outlet for the fierce need to express his psyche, Smith's drawings of the 1950s

and 1960s are emotionally articulate declarations of his identity. Looking back on his early art education and the role of gesture and self-expression, Smith reflected in 1960:

There are a lot of things I wish people had taught me. I wish somebody had taught me to draw in proportion to my own size, to draw as freely and as easily, with the same movements that I dressed myself with, or that I ate with, or worked with in the factory. Instead, I was required to use a little brush, a little pencil, to work on a little area, which put me into a position of knitting—not exactly my forte. . . . I think that the first thing I should have been taught was to work on great big paper, big sizes to utilize my natural movements towards what we call art. I think the freedom of gesture and the courage to act are more important than trying to make a design.[2]

Smith, freed from the search for a specific subject and intent on releasing energies through the pure act of creation, drew constantly, searching for a viable means of expression. He contended that the ideal creative state had no barriers, asserting:

There are no rights and wrongs. The more you meet a challenge, the more your potential may become. The one rule is that there may be no rules![3]

Some of his most beautiful gestural works are calligraphic in nature, exploring the line with a nervous force and intensity (see No. 44, 47, 48, 52, 53, 55, and 57). Smith addressed the challenge of the line with a sensuously quick brush, nurturing his need for expression by making rich strokes of ink mixed with egg yolks. He also indulged his spirit by drawing whimsical-looking shapes that are almost figural in conception, yet that verge on the abstract (see No. 45 and 46). By the mid- to late 1950s Smith drew his most gestural compositions to date, celebrating the act of drawing with joyful colors and unusual shapes (see No. 49, 50, 51, 56, 58, and 59). These exuberantly rendered compositions, often vacillating between the elegant and the garish, are the most painterly of Smith's drawings, and exude the dynamic vitality of the man. Speaking about the juxtaposition of these qualities, Smith observed:

My sculpture and especially my drawings relate to my past works, the 3 or 4 works in progress and to the visionary projection of what the next sculptures are to be. One of these projections is to push beauty to the very edge of rawness. To push beauty and imagination farther towards the limit of accepted state, to keep it moving, and to keep the edge moving, to shove it as far as possible towards that precipitous edge where beauty balances but does not topple over the edge of the vulgar.[4]

The rawness of the shapes and the juxtaposition of vivid, often clashing, colors in these drawings is a testament to the kinetic forces that Smith so desperately needed to expel. The cool elegance of No. 50 (see color plate 4) and 51, with the pinks and blues residing comfortably next to subtle shades of gray and brown, contrasts sharply with the aggressive, vibrant energy of some of the other colorful drawings, such as No. 49, 56, 58, and 59. Smith explored the power of the brushstroke to its limits in all of these drawings but especially in No. 54 and 55. Although two years separate these drawings, they share certain features, with their rich textures generated by the numerous jagged strokes. No. 55 (see color plate 5) is especially beautiful with its subtly luminous streaks of blue and yellow highlighting the two abstractly calligraphic rows of ink. A letter that Smith wrote to Frankenthaler and Motherwell in 1964 contains a passage that closely relates to the lushly textured shapes of the drawings of the late 1950s and early 1960s:

I've been thinking about shapes lately just black shapes—from the center out—as a return with a little more maturity than I had in some I made four years ago—but then I've always had that silhouette behind things.[5]

The gestural drawings, while exploring the range and force of Smith's imagination, reflect the boundless energy and spontaneous exuberance with which he pursued every activity. These drawings, more than any others, are keen affirmations of Smith's identity, expressing the powerful emotion and spirit contained within the man.

Early in his career, Smith frequently drew numerous studies on single pages of his sketchbook. Sometimes ideas for sculpture or simply studies of movement, these drawings were usually variations on a stream of related thoughts or images. Although differing slightly in size and character, the sketches were always related in the progression of the images and in the spontaneity of their creation. In the 1930s the subjects were loosely strewn on the page (see No. 23), while those of the 1940s were usually lined up as if on parade.[1] Smith must have worked from left to right, since the imagery moving to the right became more elaborate and articulated and the brushwork became progressively looser. Sometimes he made two rows of figures on the sheet but more often just one. During the 1940s Smith began to use this method of making studies as formal drawings on large sheets rather than just in his sketchbooks. His imagery at this time was often biomorphic and surreal in character, radiating a heightened sense of energetic movement and freedom.[2]

By the early 1950s, Smith began to explore the gesture in relation to the figure. His drawings of figural groups of this period are linear and retain a spontaneity, yet the sense of animation is less prevalent than that of his imagery of the 1940s. These figures, who march blithely or majestically across the page, are known as personages (see color plate 6). Smith used the term "personage" with some of his sculpture, and since these drawings are characterized by similar elements—hieratic attitude, abstract features, and vertical stance—they also deserve this label. Usually standing or striding, the personages are aloof, watchful, and pensive. Although gestural in conception, they closely reflect the figural sculpture Smith was creating concurrently—specifically, *The Hero*, 1951–1952 (K256, The Brooklyn Museum), *Portrait of a Young Girl*, 1954 (K327, Collection of Norma Braman), *Sitting Printer*, 1954 (K328, Storm King Art Center), *The Iron Woman*, 1954-1958 (K372, Storm King Art Center; see fig. 4), and of course the Tanktotems,

Forgings, and Sentinels.

The 1950s personages are vertical, linear, spiney abstractions with various numbers of appendages, such as legs, breasts, and male genitalia, arbitrarily attached (see No. 61 and 65, color plate 7). Some personages are defined by numerous lines and curves and are fluid improvisations (see No. 60 and 65). Others are rigidly linear and severe in their simple geometric austerity (see No. 66 and 70). Some of the figures are reminiscent of primitive or African art in their stature, distance, androgynous features, and totemlike stance (see No. 62 and 64).[3] Certain figures are frontal, while others are seen in profile. Smith executed his personages in a variety of colors, showing that he was aware of the powers of orange, red, or green.

No. 68 is very unusual in its six calligraphic, boldy rendered presences. Hieroglyphic in attitude, the elegant figures are similar to the Japanese "running" style of writing in which the characters are connected as they wind down the page. Although the drawing is gestural in concept, each carefully modulated stroke illustrates the strict control that Smith exercised over his brush. The spontaneity and the abstractly flowing lines make this a powerful and beautiful example of the virtuosity and restraint Smith simultaneously tried to express.

Certainly the later personages included in the exhibition are the most gestural. No. 70, with its seven brushstrokes, relates directly to the Forgings in its subtly undulating lines. Smith spoke about the Forgings in a talk given at Bennington College shortly before his death:

That's a sculpture about seven or eight or nine feet high, and it is just one single bar forged; but I don't think I could ever make a sculpture like that without making three hundred or four hundred drawings a year—I think it has to develop that way. If you are interested in making a vertical, simple vertical with the development of a drawing concept. I was wondering about a line, you see; here's the center part of it, and this form in here.... And it is a drawing line really. I would never have done that if I hadn't been interested in drawing lines. I think that is about nine feet high, and a very skinny one.[4]

As well as elaborating on the interrelationship of drawing and sculpture, Smith also revealed his concern for the distillation of form. The simplicity and formality emanating from these rhythmic strokes is reinforced by the gentle curves in the lines, delineating heads or torsos. There is a tranquil presence to these personages that stand so rigidly aloof.

In sharp contrast to this drawing is No. 72, $\Delta\Sigma$ *Prov. 1956–19*, which was executed at Provincetown. With its heavy, frantic marks, this work has an aggressive quality: the figures, made of lines of varied heights and widths, stand on a common ground or base, and each stroke resonates energy and conflict. The texture of this drawing is rich, and each figure has a depth not evident in the other, more linear, personages. As the most gestural personage in the exhibition, this drawing underscores the freedom and expressive nature that was intrinsic to Smith and his contemporaries.

These collective personages maintain a formality and a remote, impersonal presence not evident in Smith's other figural drawings. Although independent beings, each figure is related in stance, painterly qualities, and spontaneous energy to the others depicted on a particular sheet.

In the late 1950s Smith began to make a series of drawings and paintings that were unique in their innovative technical process and language.[1] He probably developed this technique accidentally, while making sculpture. By painting large white rectangles on his studio floor, Smith in effect made large sheets of paper on which he placed various elements for the sculpture currently in progress. On this neutral background, Smith could manipulate his steel pieces with freedom and eventually weld the forms together when his vision had crystallized. While welding these elements together, Smith discovered that the surrounding painted areas were burned black by the flying sparks. As E. A. Carmean, Jr., observes, the ensuing result was:

A negative image of the sculpture in the untouched white. It is likely that Smith transferred this sculptural image back into his drawings/studies, replacing the shower of sparks with the spraying of paint.[2]

In the sprayed drawings, Smith placed scraps of metal, paper, and other objects with interesting geometric shapes on the sheet of paper. He then sprayed his design from various angles with paint or enamel, often using several colors. The opaque background became a transparent atmosphere with the addition of flecks of metallic colors. The background colors, arbitrarily chosen once again, do not refer to any specific image or landscape but are used for contrast and emphasis. As a result, these drawings have a richness and depth because of the texture of the medium and the method of application (see color plate 8). The mechanical technique and crisply defined shapes could convey an impersonal, remote attitude to the drawing; to counteract this possibility, Smith often highlighted the unsprayed areas with oil paint. The brushstrokes, obviously painted by hand, lend a sense of intimacy and individuality to the inpainted sprays.

The images in the sprayed drawings were sometimes ideas for sculptures never executed (see No. 41, 73, 74, 75, and 76) or final studies of actual pieces (see No. 40 and 42), but more often they were simply gestural abstractions floating in an astral galaxy or landscape (see No. 19, 77, 78, 79, 80, 81, 82, 83, and 84). Smith, in the interview with David Sylvester, spoke about making sculpture in a way that related appropriately to the accidental nature of the sprayed drawings:

They can begin with any idea. They can begin with a found object, they can begin with no object, they can begin sometimes even when I'm sweeping the floor and I stumble and kick a few parts and happen to throw [them] into an alignment that sets me off in thinking and sets off a vision of how it would finish if it all had that kind of accidental beauty to it. I want to be like a poet, in a sense.[3]

In addition to the concern for accident and improvisation, Smith was fascinated with the challenge of gravity and weightlessness, and the free-floating forms of the sprays display this interest as they simultaneously emerge from and recede into space. With the gestural sprays, the exact delineation of the forms is often ambiguous—it is an elusive image that plays with the optic nerve. The blurred edges of some of the negative areas emphasize the ethereal atmospheric space beyond. The diaphanous aspect of the paint, combined with the forms—either crisply defined or with rough, indistinct edges—make the sense of space and recession a dominant feature in all of the sprays. The surface of these works shimmers; there is also a sense of movement because of the iridescent surface and opalescent texture (see No. 80) and because some of the forms leave a wake (see No. 83), which could possibly have been inspired by the trails of the sparks that the welding torch made. These wakes add to the intergalactic effect, reminding the viewer of falling stars and comets. The flecks of paint, which can be construed as stars, also emphasize this celestial quality.

The sprays, with their elusive forms floating in a stellar landscape, show Smith's awareness of nature, with its constantly changing forms, colors, light, rhythms, and life. But more important, the sprays illustrate Smith's awe for the vastness of the universe and the vulnerability of the lone man. Motherwell wrote of Smith in this context in 1950, already perceiving his friend's fascination with this sublime thought.

When I saw that David places his work against the mountains and sky, the impulse was plain, an ineffable desire to see his humanness related to exterior reality, to nature at least if not man, for the marvel of the felt scale that exists between a true work and the immovable world, the relation that makes both human.[4]

Thus the sprays, by combining the ideas of found object and fortuitous arrangement, culminate the expression of Smith's feelings about man's relationship to his surroundings as tangibly as his late sculpture does.

NOTES

Archives citations refer to the Archives of American Art, Smithsonian Institution. ND-Smith refers to the David Smith Papers or to other collections on microfilm. The first figure is the microfilm roll number, while the next is the frame number. All material from the Archives is quoted with the permission of the Collection of Candida and Rebecca Smith.

INTRODUCTION

1. McCoy 1973, 120. From a lecture given at a forum conducted by George Rickey at Sophie Newcomb College, Tulane University in New Orleans, 21 March 1955.

2. McCoy 1973, 137.

3. Archives, ND-Smith 4/387–388. At that time in his life, Smith did produce an extraordinary number of drawings but never as many as 300–400 annually (conversation with Peter Stevens, September 1983). Some evenings he would execute a dozen or more in a row, working out related images in various sequences. Following Smith's practice in titling his drawings, the Smith family has decided to use his inscription as the proper title (conversation with Peter Stevens, May 1984).

4. Archives, ND-Smith 1/004. One of Smith's report cards from Ohio University.

5. Gray 1968, 24.

6. See the exhibition catalogue, *Jan Matulka, 1890–1972* (Washington, D.C.: Smithsonian Institution Press, 1980). The chapter written by Dorothy Dehner, "Memories of Jan Matulka," discusses the Smiths' rapport with Matulka.

7. Gray 1968, 24.

8. Fry and McClintic 1982, 10.

9. Archives, ND-Smith 4/386.

10. See Krauss 1977, 1–3.

11. Archives, ND-Smith 4/388–389.

12. "Self-Portrait of an American Sculptor," interview for the British Broadcasting Corporation, 16 June 1961. A tape and transcript are housed at the Archives. Smith probably used the words "drawing" and "painting" interchangeably.

13. Archives, ND-Smith. Rolls 3 and 4 include 48 sketchbooks, which Smith kept from the mid-1930s until his death.

14. Archives, ND-Smith 3/452–462. See also Wilkin 1981, 10.

15. Archives, ND-Smith 3/453 and 3/459. See also Cummings 1979, 13.

16. "Is Today's Artist with or against the Past?" interview with David Smith, *ARTnews* 57 (September 1958): 62.

17. Kramer 1960, 29 and 31.

18. Krauss 1971, 67.

19. We are fortunate that so much of Smith's writing has been made available through the Smith family and the Archives of American Art because his writing provides insight into and perspective on his oeuvre. His thoughts were penned as religiously as his art was executed.

20. Smith 1969, 46. See also de Kooning 1951. After a spring 1951 visit to Smith's studio, Elaine de Kooning used his notes of their conversation as background material for her article.

21. Gray 1968, 169.

22. McCoy 1973, 83. From a paper by Smith presented at "The New Sculpture," held at The Museum of Modern Art, 21 February 1952.

23. Cummings 1979, 23.

24. Archives, ND-Smith D/321, written 6 October 1957. From papers lent to the Archives by Helen Frankenthaler and Robert Motherwell.

25. Archives, ND-Smith 4/369–370. For the final text, delivered 23 August 1952 in Woodstock, New York, see McCoy 1973, 86–88.

26. Archives, ND-Smith 4/461.

THE FIGURE

1. See No. 25 and 26 and the following sculptures in Krauss 1977: K147, K148, K163, K164, and K177 to name a few. (A "K" number simply refers to entries in the Krauss volume.)

2. See No. 6 and 24 and K115, K135, K139, and K193 among others.

3. Greenberg, Clement, "Critical Comment," in "A Tribute to One of the Greatest Sculptors of Our Time, David Smith, 1906–1965," *Art in America* 54 (January–February 1966):32.

THE LANDSCAPE

1. Smith 1969, 56.

2. Cummings 1979, 12.

3. Gray 1968, 71.

4. See Fry and McClintic 1982, 132, and their catalogue note 19.

5. See Fry and McClintic 1982, 83, plate 55, for a color reproduction.

6. Archives, ND-Smith D/300. From a letter to Helen Frankenthaler, August 1956.

STUDIES FOR SCULPTURE

1. Archives, ND-Smith 3/1339. From sketchbook 40.

2. Archives, ND-Smith 4/357.

3. Gray 1968, 55.

4. Archives, ND-Smith, unfilmed papers, Box 20. From a letter to Edgar Levy, 1 September 1945.

5. A pencil drawing almost identical to this oil drawing exists (73-DS.1), which was included in the Whitney Museum of American Art's 1979 exhibition (no. 3). Both Picasso's *The Studio*, 1927–1928 (The Museum of Modern Art), and Gorky's *Organization*, c. 1936 (National Gallery of Art), are similar in style.

6. Archives, ND-Smith, unfilmed papers, Box 16. For the "Medals for Dishonor" exhibition catalogue, Willard Gallery, 5–23 November 1940.

THE GESTURES

1. Archives, ND-Smith 4/812.

2. Archives, ND-Smith D/384–385. From a draft for a speech delivered at the Eighteenth Conference of the National Committee on Art Education at The Museum of Modern Art, 5 May 1960. For the final text, see McCoy 1973, 149.

3. McCoy 1973, 183. From an interview with Thomas B. Hess in June 1964, published originally in an exhibition catalogue, Marlborough-Gerson Gallery, October 1964.

4. Archives, ND-Smith 4/388. Below this note, Smith wrote the definition of the word "vulgar" from the Oxford English Dictionary: "Vulgar meaning 'offending against refinement of good taste.'"

5. Archives, ND-Smith D/376. From a letter to Frankenthaler and Motherwell, 3 August 1964.

THE PERSONAGES

1. The idea of lining up various related images on one page was not a new one. Picasso had also worked this way, and one such drawing was illustrated in the first issue of *Minotaure*, published in 1933 by Albert Skira. See Picasso, "Une anatomie—dessins de Picasso," *Minotaure* 1, no. 1 (1933):33–37. Graham may have shown this magazine to Smith, who certainly saw the exhibition, "Picasso: Fifty Years of His Art," assembled by Alfred Barr for The Museum of Modern Art in 1946. On page 183 the catalogue reproduced one of the drawings illustrated in the issue of *Minotaure*.

2. See Cummings 1979, figure 17 and 18. Executed in 1944, some of these studies became sculptures during that year.

3. For a thoughtful and provocative discussion on Smith and the totem, see Krauss 1971, 88–116.

4. Baro 1965, 50. From a slide lecture Smith delivered at Bennington College in Vermont, 12 May 1965.

THE SPRAYS

1. Paul Klee had used a sprayed stencil technique in the 1920s, spraying over geometrically shaped stencils with watercolors, whose subtly modulated lines and planes created ethereal landscapes. Smith may have been influenced by Klee's technique, but it seems more likely that Smith developed his sprayed works independently.

2. Carmean 1982, 27–28.

3. "Self-Portrait of an American Sculptor," interview for the British Broadcasting Corporation, 16 June 1961.

4. Robert Motherwell, from the preface to "David Smith," an exhibition catalogue, Willard Gallery, 18 April–13 May 1950.

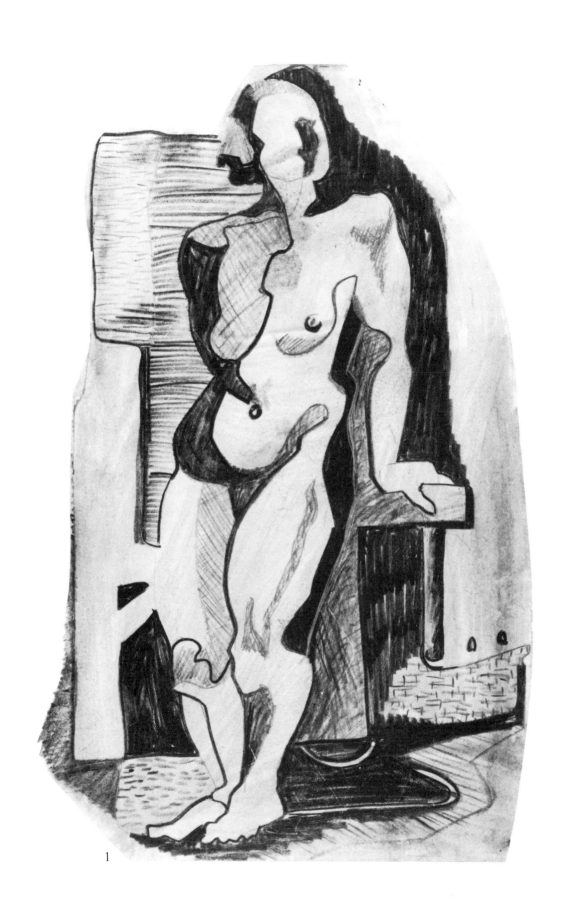

1

Smith signed and dated many of his drawings. Where he did so, the inscription serves as the title. Descriptive titles are in parentheses; the figures in brackets are the identification numbers for the Collection of Candida and Rebecca Smith.

1. *Untitled* [73–30.3, #8], c. 1930. Charcoal and pencil. 19½ × 12½ inches (49.5 × 31.8 cm). No inscription.

2. *D.S. 1934 / Nov.* [73–34.8], 1934. Pen and ink. 8½ × 11 inches (21.6 × 27.9 cm). Inscribed, upper right.

3. *Untitled* [73–34.15B], 1934. Pen and ink. 8½ × 11 inches (21.6 × 27.9 cm). No inscription.

4. *Untitled* [73–37.1E], 1937. Pastel and pencil. 20 × 13 inches (50.8 × 33.0 cm). No inscription.

5. *Martha Graham—Photo Barbara Morgan* [73–38.3C], 1938. Pencil and wash. 12 × 19 inches (30.5 × 48.3 cm). Inscribed, upper center.

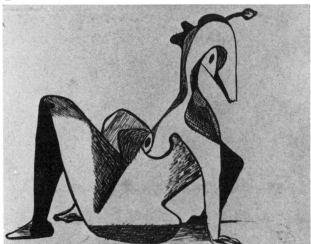

2

3

5

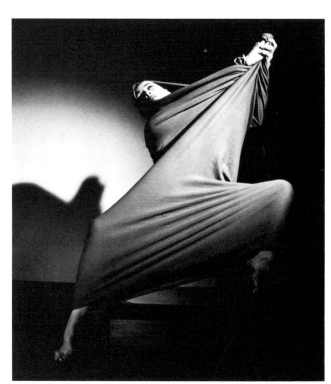

Fig. 1. Barbara Morgan, *Martha Graham: Lamentation (Oblique)*, 1935. Courtesy Barbara Morgan, New York.

6. *Untitled* (ballet à deux) [73–38.5], 1938. Oil. 10 × 13½ inches (25.4 × 34.3 cm). No inscription.

7. **ΔΣ** *1/14–52* [73–52.130], 1952. Egg ink and ink. 26 × 20 inches (66.0 × 50.8 cm). Inscribed, upper right.

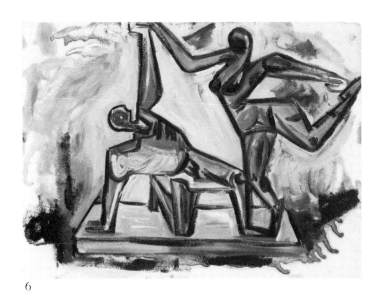

6

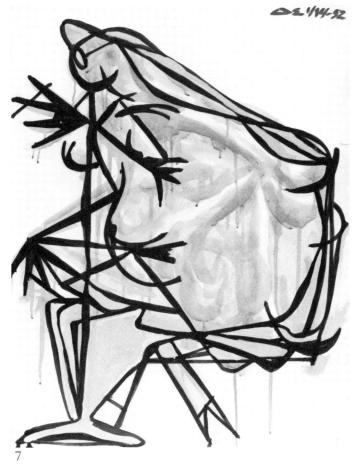

7

8. ΔΣ *1/6/55 M. NY* ③ [73–55.33], 1955. Egg ink and tempera. 17½ × 22½ inches (44.5 × 57.2 cm). Inscribed, lower right.

9. *David Smith DO 5—1963* (nudes from Dort series) [73–63.30], 1963. Egg ink. 25¾ × 20 inches (65.4 × 50.8 cm). Inscribed on pink smear, lower center.

10. *David S. / DO 13 / 1963* (gestural nude from Dort series) [73–63.40], 1963. Egg ink. 17½ × 22½ inches (44.5 × 57.2 cm). Inscribed on pink smear, lower right.

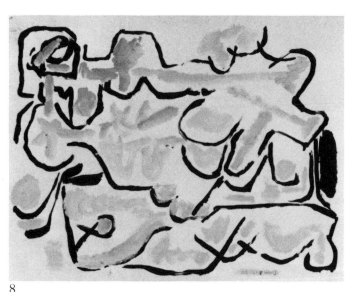

8

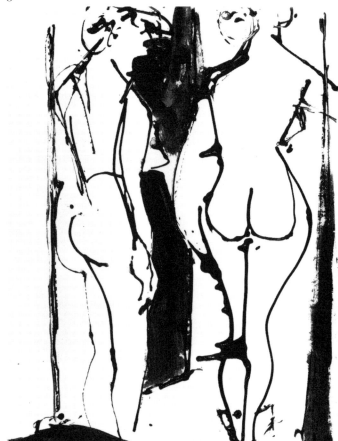

9

11. *Untitled* (Virgin Islands landscape) [73–32.1, #1], 1932. Pen and ink and wash. 17¼ × 27⅜ inches (43.8 × 69.5 inches). No inscription.

12. *D.S. / 1932* (Virgin Islands landscape) [73–32.3], 1932. Pen and wash and ink. 11 × 8½ inches (27.9 × 21.6 cm). Inscribed, lower right.

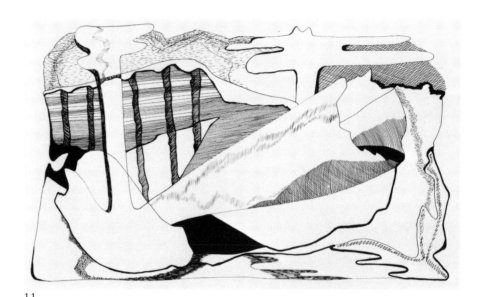

11

12

13. ΔΣ *11–3–51* [73–51.4], 1951. Egg ink and tempera. 24¼ × 19¾ inches (61.6 × 50.2 cm). Inscribed, upper left; verso, another drawing and a Willard Gallery sticker with the title "Drawing for a Sculpture."

14. ΔΣ *5/2/52* [73–52.105], 1952. Egg ink. 18 × 23¼ inches (45.7 × 59.1cm). Inscribed, upper right.

15. *Untitled* [73–52.137], 1952. Egg ink. 18 × 23¼ inches (45.7 × 59.1 cm). No inscription.

13

Fig. 2. *Hudson River Landscape*, 1951. Courtesy Whitney Museum of American Art, New York.

16. ΔΣ *1/6/55—ΔΣ 1/6/54 M.M / 54* [73–55.144], 1955. Egg ink. 17½ × 22½ inches (44.5 × 57.2 cm). Inscribed, upper left (upside down) and lower right. The discrepancy in dates is most likely explained by the change of year from 1954 to 1955, a time when many people misdate their correspondence. Stylistically, this drawings relates more to work done in late 1954 and 1955—it is looser and more expressive.

16

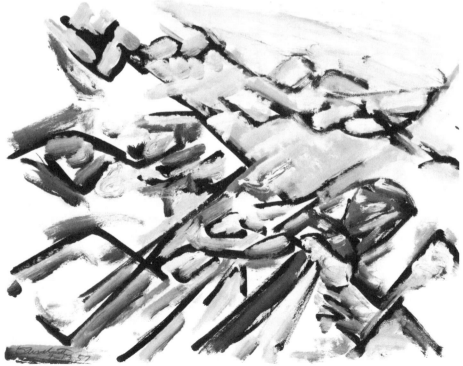

18

17. ΔΣ *Prov 1956—18* [73–56.57], 1956. Egg ink. 22¼ × 30¾ inches (56.5 × 78.1 cm). Inscribed, lower right.

18. *David Smith / 9/13/57* [73–57.110], 1957. Egg ink, oil, and tempera. 15¾ × 20⅜ inches (40.0 × 51.8 cm). Inscribed on turquoise smear, lower left.

19. ΔΣ *12–3–60* [73–60.175], 1960. Spray paint. 11½ × 17¾ inches (29.2 × 45.1 cm). Inscribed on ivory smear, lower right.

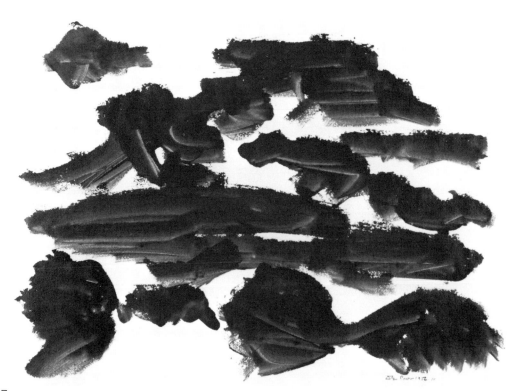

17

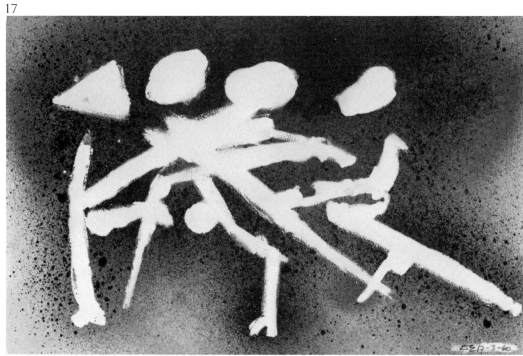

19

20. *Untitled* (Voltri #9) [73–62.4], 1962. Egg ink.
19 × 24½ inches (48.3 × 62.2 cm). No inscription.

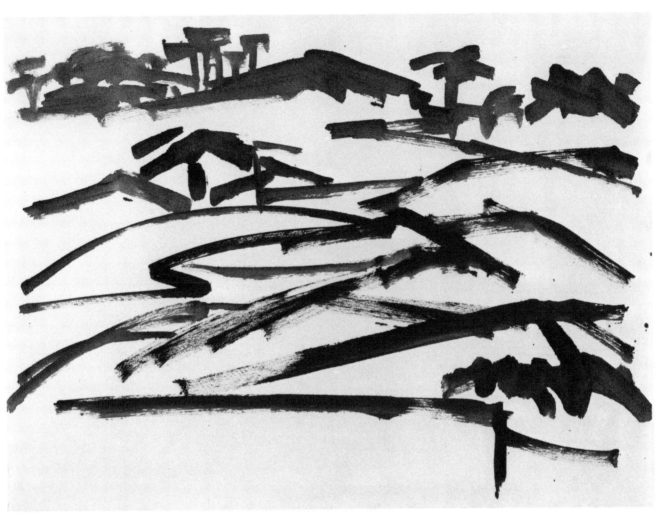

20

21. *Untitled* [73–30.5A], c. 1934. Oil. 10×14 inches (25.4×35.6 cm). No inscription.

22. *Untitled* (study for "Construction with Points") [73–37.6], 1937. Pastel. 22×17 inches (55.9×43.2 cm). No inscription.

23. ΔΣ / *38/39* (study for "Munition Makers") [73–38.13], 1938–1939. Pen and ink and wash. 8½×14 inches (21.6×35.6 cm). Inscribed, lower left.

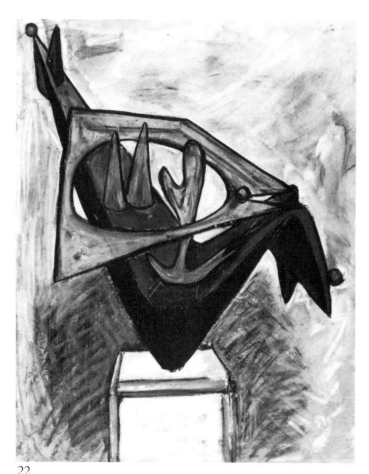

22

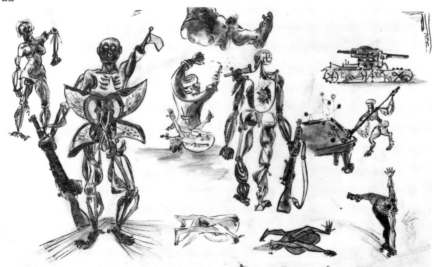

23

24. ΔΣ [73–39.4], 1939. Tempera and pastel. 12 × 19 inches (30.5 × 48.3 cm). Inscribed, lower right.

25. ΔΣ [73–39.5], 1939. Oil, pastel, and tempera. 12 × 19 inches (30.5 × 48.3 cm). Inscribed, lower right.

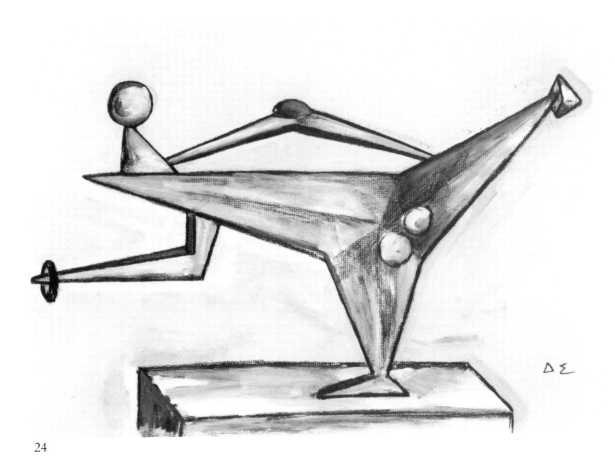

24

26. *Woman Music 1944 / Woman Music / David Smith 1944*
(study for "Woman Music") [73–44.3], 1944. Ink and
wash. 25¼ × 19⅝ inches (59.1 × 49.9 cm). Inscribed,
lower right; left margin: chestnut wood 5 ft (1st figure).

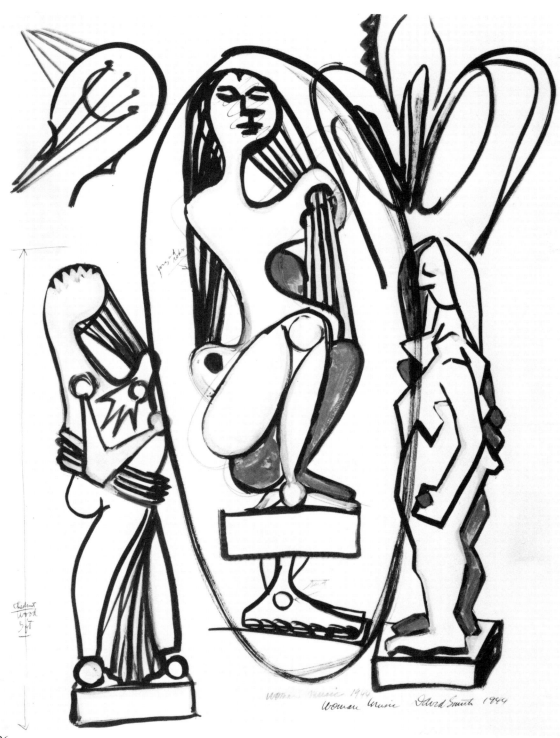

27. *David Smith 1946* (study for "Personage from Stove City") [73–46.1], 1946. Oil. 20 × 26¼ inches (50.8 × 66.7 cm). Inscribed, upper right; overall with numerous instructions for sculpture.

28. *David Smith 1946* [73–46.13], 1946. Oil and egg ink. 20 × 25½ inches (50.8 × 64.8 cm). Inscribed, lower right.

29. *ΔΣ 7–51* [73–51.37], 1951. Egg ink and tempera. 22¼ × 17 inches (56.5 × 43.2 cm). Inscribed, upper left.

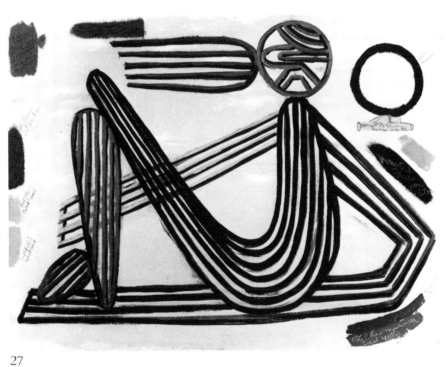

27

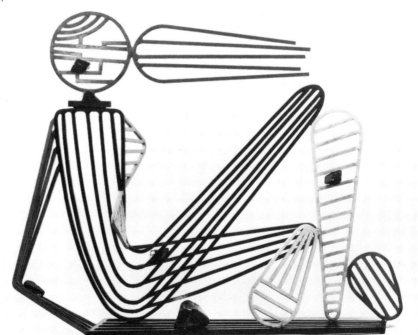

Fig. 3. *Personage from Stove City*, 1946. Courtesy Collection of Candida and Rebecca Smith.

30. *Untitled* [73–52.132], 1952. Egg ink. 20 × 26 inches (50.8 × 66.0 cm). No inscription.

31. ΔΣ *5/5/52* [73–52.136], 1952. Egg ink and tempera. 18 × 23¼ inches (45.7 × 59.1 cm). Inscribed, upper left.

32. ΔΣ *3/1/52* [73–52.143], 1952. Egg ink and tempera. 18 × 23 inches (45.7 × 58.4 cm). Inscribed, upper right center.

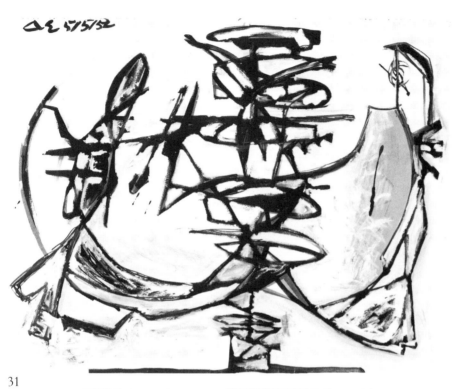

31

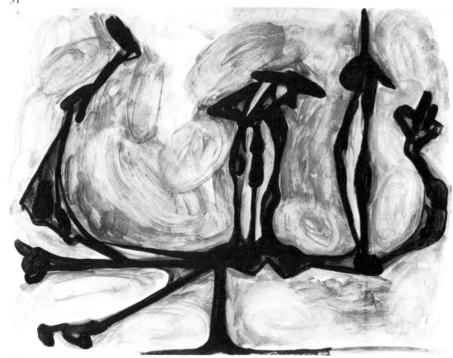

32

33. ΔΣ *9/4/52* (study for "Tanktotems") [73–53.2], 1952. Tempera and ink. 18 × 23⅜ inches (45.7 × 59.4 cm). Inscribed, bottom center.

34. ΔΣ *53–54* [73–53.79], 1953–1954. Collage and tempera. 20 × 26 inches (50.8 × 66.0 cm). Inscribed, upper left center.

35. ΔΣ *2/16/54* [73–54.4], 1954. Egg ink and tempera. 42¾ × 30 inches (108.6 × 76.2 cm). Inscribed on black smear, lower right.

36. *Untitled* (study for Zigs and Cubis) [73–55.140], 1954. Egg ink and tempera. 18 × 23 inches (45.7 × 58.4 cm). No inscription.

37. *David Smith 8/23/56* [73–56.50], 1956. Tempera. 18 × 23 inches (45.7 × 50.8 cm). Inscribed, lower left.

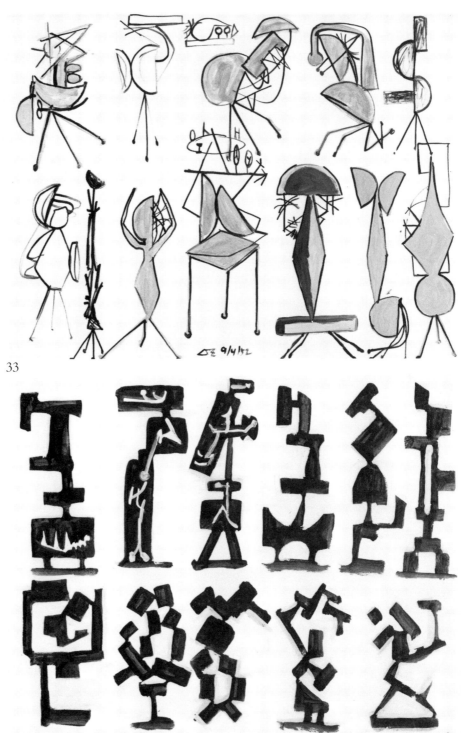

33

36

38. *David Smith 7/11/57* [73–57.46], 1957. Oil and tempera. 26½ × 20¼ inches (66.7 × 51.4 cm). Inscribed, lower right.

39. *Untitled* [73–57.129], 1957. Egg ink. 20¼ × 26 inches (51.4 × 66.0 cm). No inscription.

40. *Untitled* (study for "Windtotem") [73–61.30], 1961. Spray paint and oil overlay. 17½ × 11½ inches (44.5 × 29.2 cm). No inscription.

41. *3 ΔΣ 3–17–63* [73–63.188], 1963. Spray paint. 16 × 11½ inches (40.6 × 29.2 cm). Inscribed, lower center.

42. *1 ΔΣ 3–16–63* (study for "Cubi VI") [73–63.193], 1963. Spray paint and oil overlay. 16 × 11½ inches (40.6 × 29.2 cm). Inscribed, lower left; written up left side: Finished Mar 21–1963 ht 118 [erasure] Stainless 304.

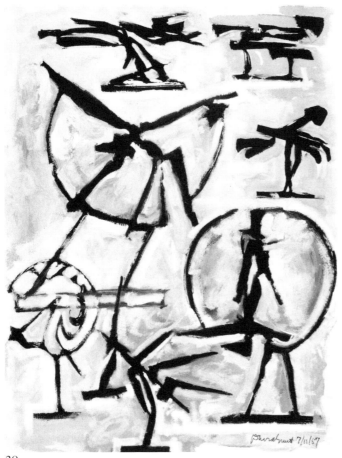

38

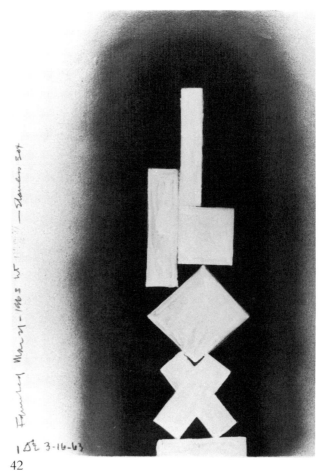

42

43. *3 / 33 DS* (Virgin Islands study) [73–33.6], 1933.
Tempera, lacquered forms, and lined paper glued onto
linen. 14 × 17 inches (35.6 × 43.2 cm). Inscribed, lower
right.

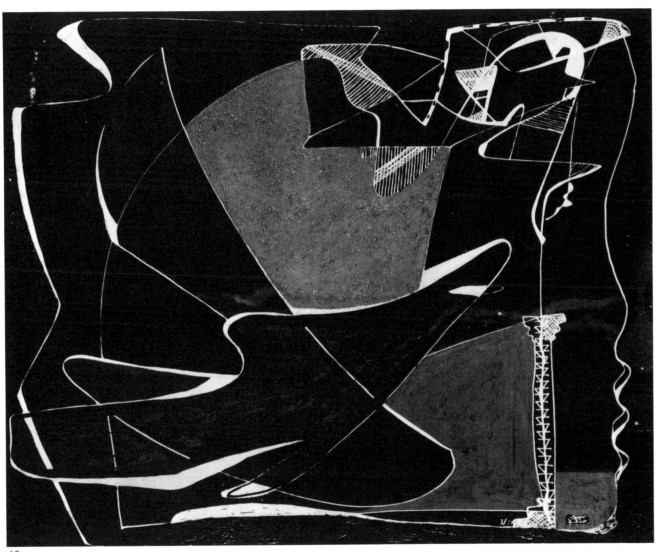

43

44. **ΔΣ** *12–30–50* [73–50.14], 1950. Egg ink, ink, tempera, and wash. 15½ × 20 inches (39.4 × 50.8 cm). Inscribed, lower right.

45. **ΔΣ** *12/12/52* [73–52.93], 1952. Egg ink. 42½ × 29¾ inches (107.3 × 75.6 cm). Inscribed, lower right.

46. **ΔΣ** *3/21/52* [73–52.104], 1952. Egg ink and ink. 18 × 23¼ inches (45.7 × 59.1 cm). Inscribed, upper right.

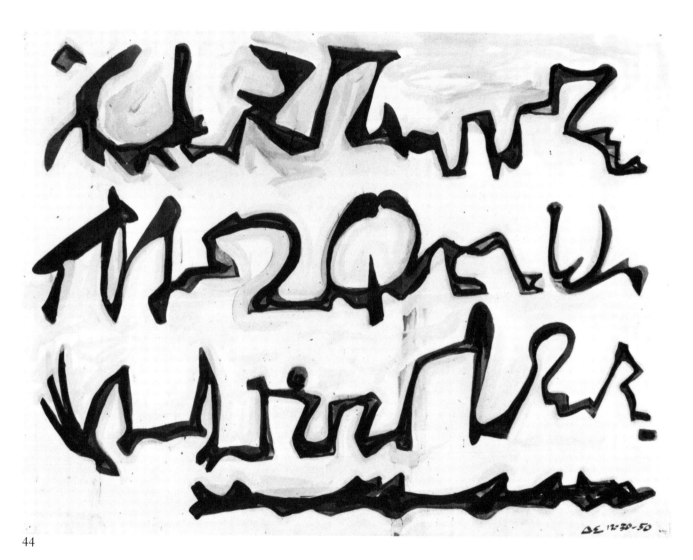

44

47. **ΔΣ** *18 / 5/4/53* [73–53.103], 1953. Egg ink.
15½ × 20¼ inches (39.4 × 51.4 cm). Inscribed, lower
right. The inscription indicates that this was the
eighteenth drawing made on 4 May 1953.

48. **ΔΣ** *1/5/55 2:30 pm* [73–55.19], 1955. Egg ink.
17½ × 22½ inches (44.5 × 57.2 cm). Inscribed, lower right.

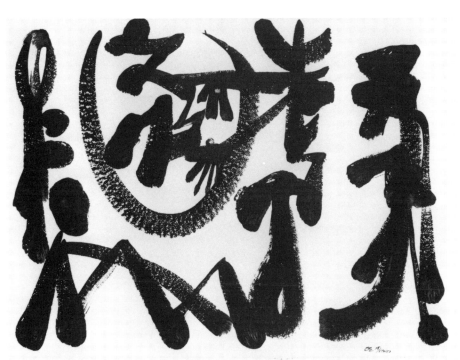

47

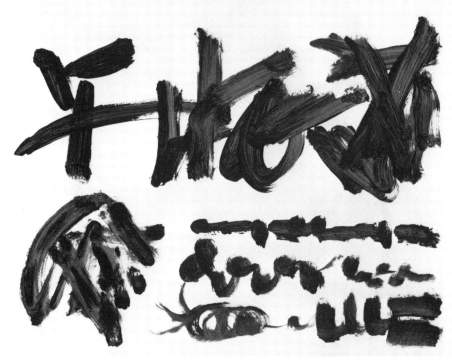

48

49. ΔΣ *12/1/57* [73–57.14], 1957. Oil. 23 × 35½ inches
(58.4 × 90.2 cm). Inscribed, lower right.

50. ΔΣ *9–18–57* [73–57.50], 1957. Oil. 20⅛ × 26¼ inches
(51.1 × 66.7 cm). Inscribed, lower right.

51. ΔΣ *9–22–57* [73–57.52], 1957. Oil and tempera.
19⅞ × 26 inches (50.5 × 66.0 cm). Inscribed, lower
right.

52. ΔΣ *56—12—57* [73–57.198], 1956–1957. Egg ink.
17½ × 22½ inches (44.5 × 57.2 cm). Inscribed, lower
right.

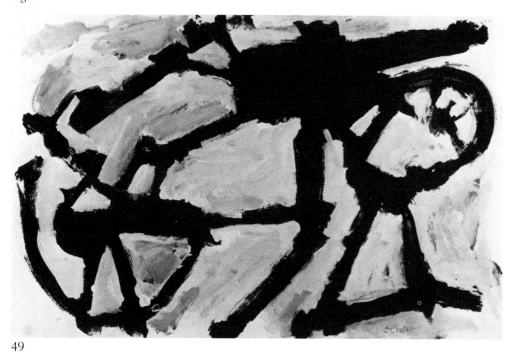

49

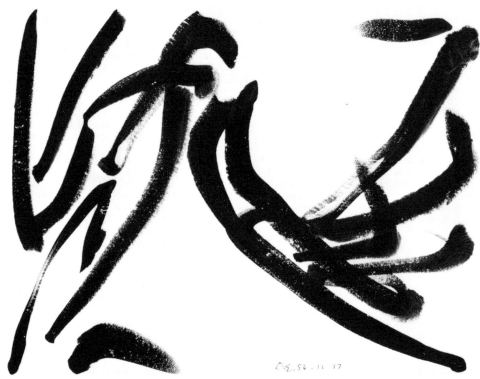

52

53. *David Smith B 5/58 19* [73–58.102], 1958. Egg ink. 19½ × 24¼ inches (49.5 × 61.6 cm). Inscribed, lower left.

54. *David Smith 5—30—⁴/₅₈* [73–58.262], 1958. Egg ink. 19¾ × 25¾ inches (50.2 × 65.4 cm). Inscribed, lower right.

55. *David Smith 1960 Ch* (Chelsea series) [73–60.17], 1960. Egg ink and tempera. 26 × 41 inches (66.0 × 104.1 cm). Inscribed, lower right.

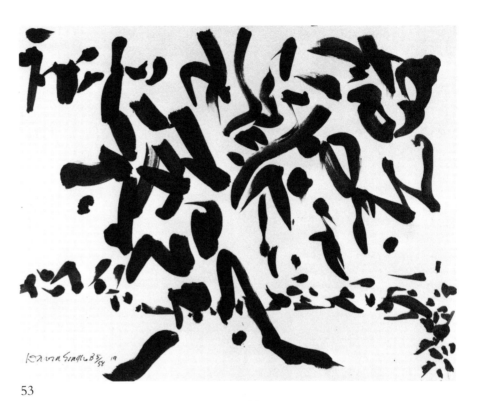

53

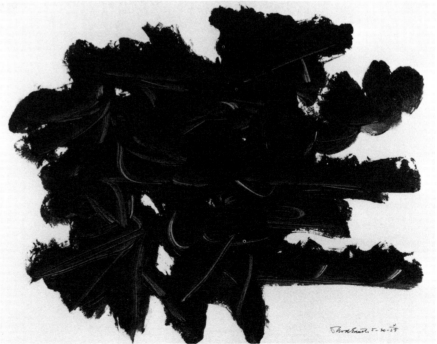

54

56. *David Smith 4–1–60 Ch* (Chelsea series) [73–60.32], 1960. Egg ink and oil. 41 × 26 inches (104.1 × 66.0 cm). Inscribed on ivory smear, lower left.

57. *Untitled* [73–60.50], 1960. Egg ink. 26¾ × 39¾ inches (68.0 × 101.0 cm). No inscription.

58. ΔΣ *11–10–60* [73–60.200], 1960. Egg ink and tempera. 10⅞ × 14⅞ inches (27.6 × 37.8 cm). Inscribed, lower right.

59. ΔΣ *11–17–60* [73–60.207], 1960. Egg ink and tempera. 10⅞ × 14⅞ inches (27.6 × 37.8 cm). Inscribed, lower right.

60. ΔΣ *7 / 5/3/53* [73–53.90], 1953. Egg ink. 15½ × 20 inches (39.4 × 50.8 cm). Inscribed, bottom center. The inscription indicates that this was the seventh drawing made on 3 May 1953.

61. ΔΣ *5 / 5/4/53* [73–53.96], 1953. Ink. 15½ × 20 inches (39.4 × 50.8 cm). Inscribed, top center.

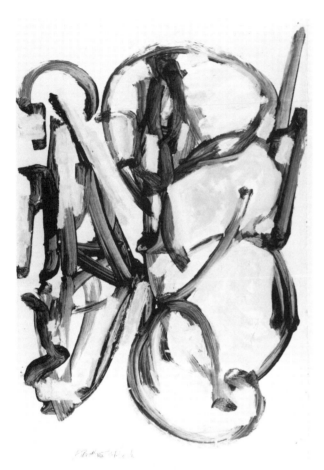

56

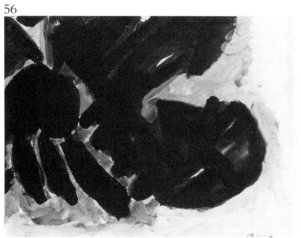

59

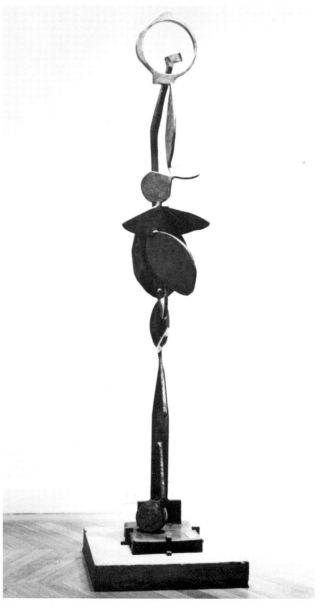

Fig. 4. *The Iron Woman*, 1954–1956. Courtesy Storm King Art Center, Mountainville, New York.

62. ΔΣ *18 / 5/3/53* [73–53.102], 1953. Egg ink.
15½ × 20¼ inches (39.4 × 51.4 cm). Inscribed, upper
right.

63. ΔΣ *5/ 5/7/53* [73–53.109], 1953. Egg ink and
tempera. 15½ × 20¼ inches (39.4 × 51.4 cm).
Inscribed, upper right.

64. *Untitled* [73–53.121], 1953. Egg ink. 18 × 24 inches
(45.7 × 61.0 cm). No inscription.

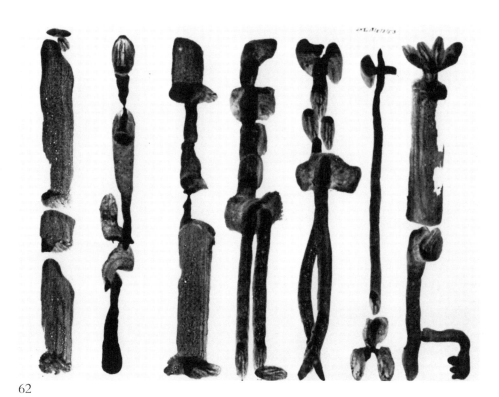

62

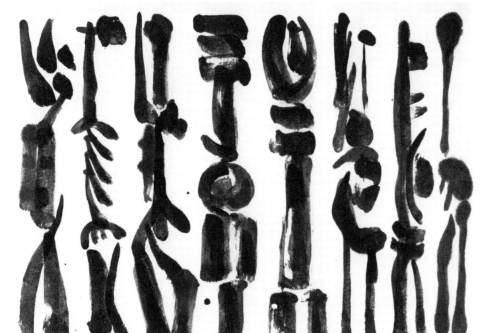

64

65. *Untitled* [73–53.127], 1953. Egg ink. 17½ × 22½ inches (44.5 × 57.2 cm). No inscription.

66. Δ∑ *4/16/53 JF* [73–53.134], 1953. Tempera. 17½ × 22½ inches (44.5 × 57.2 cm). Inscribed, lower right. The "JF" refers to Jean Freas, whom Smith had married on 6 April 1953, only ten days before making this drawing.

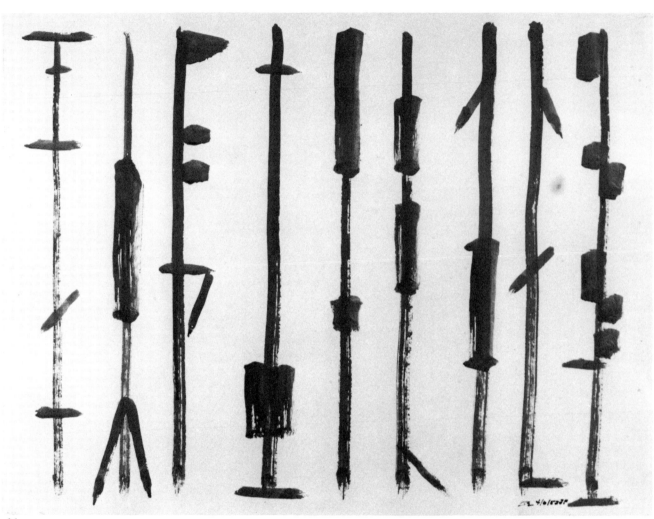

66

67. ② 2/54 [73–54.105], 1954. Egg ink. 10 × 8 inches
(25.4 × 20.3 cm). Inscribed, lower center.

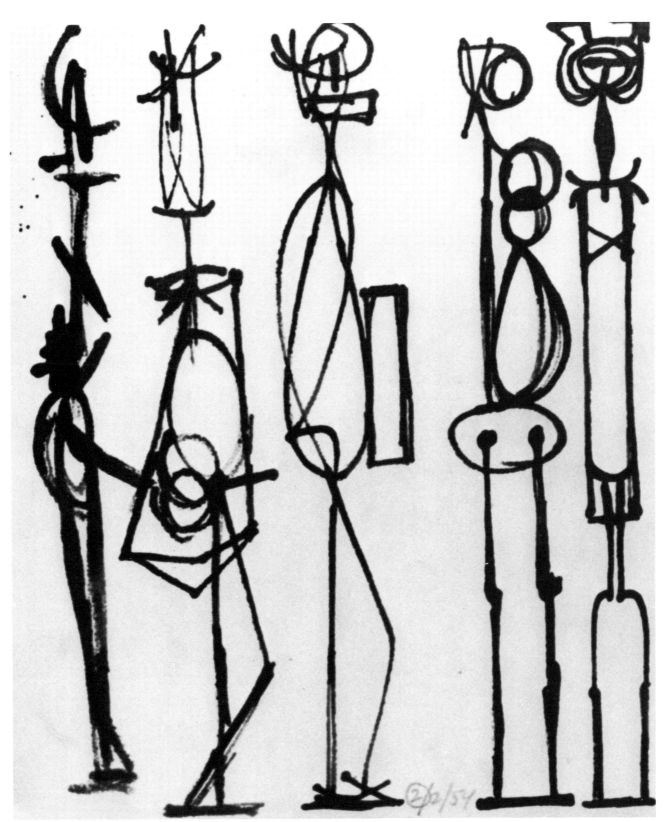

67

68. *Untitled* [73–54.155], 1955. Egg ink. 8¾ × 11½ inches (22.2 × 29.2 cm). No inscription.

69. *David Smith* / [illegible] /*54* [73–54.157A], 1954. Egg ink. 10 × 8 inches (25.4 × 20.3 cm). Inscribed on gold smear, lower right.

70. *Untitled* [73–55.70], 1955. Egg ink. 15¾ × 20¼ inches (40.0 × 51.4 cm). No inscription.

71. *Untitled* [73–55.80], 1955. Egg ink. 22½ × 17¼ inches (57.2 × 44.5 cm). No inscription.

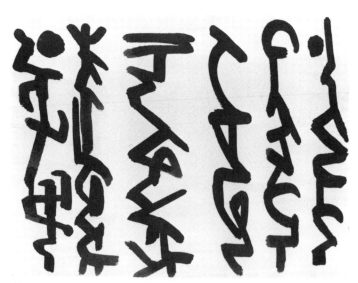

68

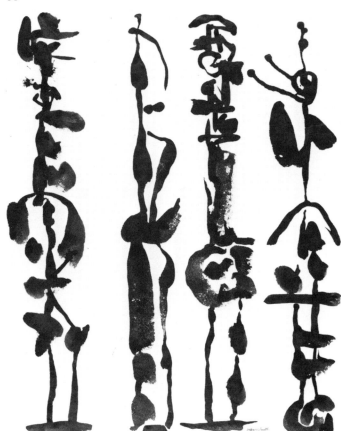

69

72. ΔΣ *Prov 1956–19* [73–56.59], 1956. Egg ink.
24 × 32½ inches (61.0 × 82.6 cm). Inscribed, lower right.

73. *Untitled* [73–59.125], 1959. Spray paint and oil
overlay. 17½ × 11½ inches (44.5 × 29.2 cm). No inscription.

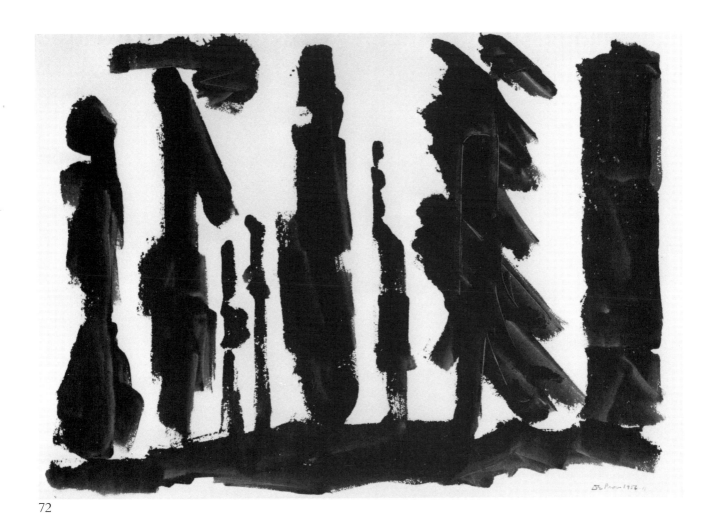

72

74. *Untitled* [73–59.131], 1959. Spray paint. 17½ × 11½ inches (44.5 × 29.2 cm). No inscription.

75. *Untitled* [73–60.186], 1960. Spray paint. 17¾ × 11½ inches (45.1 × 29.2 cm). No inscription.

76. *Untitled* [73–62.40], 1962. Spray paint. 13 × 19 inches (33.0 × 48.3 cm). No inscription.

77. *Untitled* [73–62.50], 1962. Spray paint. 11½ × 17½ inches (29.2 × 44.5 cm). No inscription.

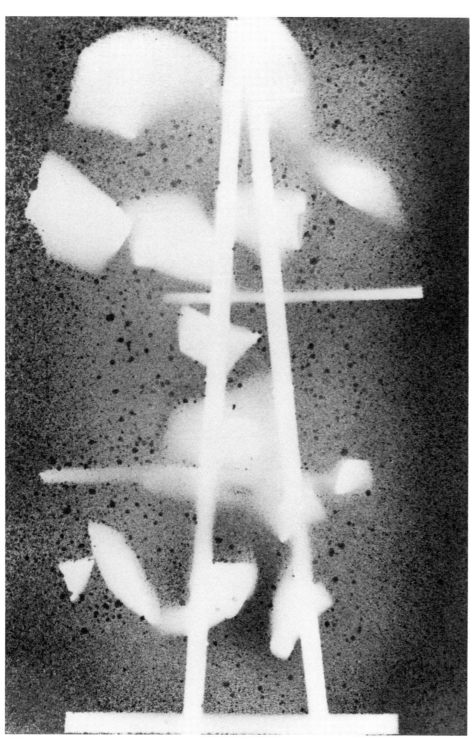

74

78. *Untitled* [73–62.64], 1962. Spray paint. 17½ × 11½ inches (44.5 × 29.2 cm). No inscription.

79. *Untitled* [73–62.138], 1962. Spray paint. 13½ × 20 inches (34.3 × 50.8 cm). No inscription.

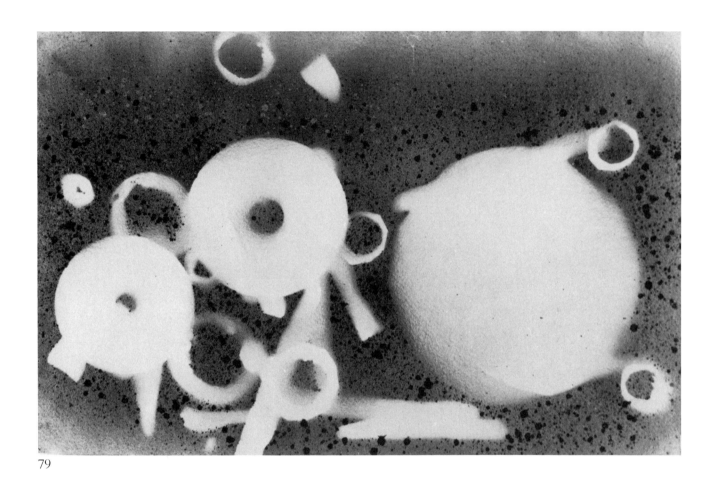

79

80. *Untitled* [73–62.192], 1962. Spray paint. 15½ × 20¼
inches (39.4 × 51.4 cm). No inscription.

81. *Untitled* [73–62.195], 1962. Spray paint. 27 × 39⅝
inches (68.6 × 98.1 cm). No inscription.

82. *Untitled* [73–62.197], 1962. Spray paint. 27 × 39⅝
inches (68.6 × 98.1 cm). No inscription.

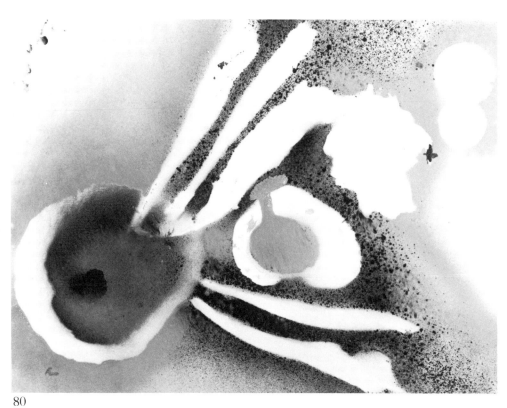

80

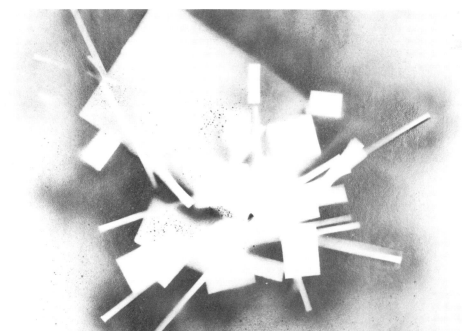

82

83. *David Smith 3–19–62* [73–62.225], 1962. Spray paint. 15¾ × 20½ inches (40.0 × 52.1 cm). Inscribed, lower right.

84. *Untitled* [73–63.153], 1963. Spray paint. 15 × 22 inches (38.1 × 55.9 cm). No inscription.

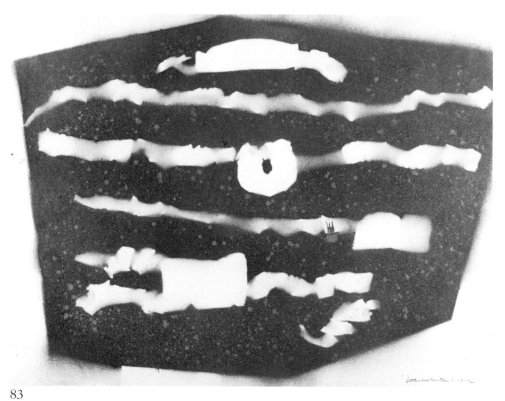

83

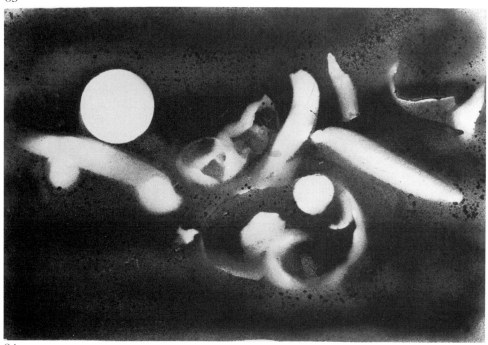

84

BIBLIOGRAPHY

This abbreviated bibliography of publications about David Smith includes the major publications and those works that are relevant to Smith's drawings. For a complete list, see Cummings 1979 (compiled by Barbara Thexton), 123–128, and Krauss 1977, 150–158. One invaluable source of information on Smith is the Archives of American Art, Smithsonian Institution, Washington, D.C. The David Smith Papers, as well as writings published by the artist, are on loan to the Archives from Candida and Rebecca Smith and provide a great source of information. For a thorough chronology of Smith's life, see Gray 1968, 24–33, which Smith wrote himself around 1950.

BARO 1965 Baro, Gene, ed. "Some Late Words from David Smith." *Art International* IX, no. 7 (20 October 1965): 47–51.

CARMEAN 1982 Carmean, E.A., Jr. *David Smith* (exhibition catalogue). Washington, D.C.: National Gallery of Art, 1982.

CONE 1966 Cone, Jane Harrison. *David Smith: 1906–1965* (exhibition catalogue). Cambridge, Massachusetts: Fogg Art Museum, Harvard University, 1966.

CUMMINGS 1979 Cummings, Paul. *David Smith, the Drawings* (exhibition catalogue). New York: Whitney Museum of American Art, 1979.

DAY 1983 Day, Holliday T. *David Smith: Spray Paintings, Drawings, Sculpture* (exhibition catalogue). Chicago: The Arts Club of Chicago, 1983.

DE KOONING 1951 de Kooning, Elaine. "David Smith Makes a Sculpture." *ARTnews* 50 (September 1951): 38–41.

FRY 1969 Fry, Edward F. *David Smith* (exhibition catalogue). New York: The Solomon R. Guggenheim Museum, 1969.

FRY AND MCCLINTIC 1982 Fry, Edward F., and Miranda McClintic. *David Smith: Painter, Sculptor, Draftsman* (exhibition catalogue). New York: George Braziller, Inc., in association with the Hirshhorn Museum and Sculpture Garden, Smithsonian Institution, Washington, D.C., 1982

GRAY 1966 Gray, Cleve, ed. "A Tribute to One of the Greatest Sculptors of Our Time, David Smith, 1906–1965." *Art in America* 54 (January–February 1966): 22–48.

GRAY 1968 Gray, Cleve, ed. *David Smith by David Smith*. New York: Holt, Rinehart and Winston, 1968.

KRAMER 1960 Kramer, Hilton. "The Sculpture of David Smith." *Arts* 34, no. 5 (February 1960): 22–43.

KRAUSS 1971 Krauss, Rosalind E. *Terminal Iron Works: The Sculpture of David Smith*. Cambridge, Massachusetts: MIT Press, 1971.

KRAUSS 1977 Krauss, Rosalind E. *The Sculpture of David Smith: A Catalogue Raisonné*. New York and London: Garland Publishing, Inc., 1977.

MARCUS 1983 Marcus, Stanley E. *David Smith: The Sculptor and His Work*. Ithaca, New York, and London: Cornell University Press, 1983.

MCCLINTIC 1979 McClintic, Miranda. *David Smith: The Hirshhorn Museum and Sculpture Garden Collection* (exhibition catalogue). Washington, D.C.: Hirshhorn Museum and Sculpture Garden, Smithsonian Institution Press, 1979.

MCCOY 1968 McCoy, Garnett. "The David Smith Papers." *Journal of the Archives of American Art* 8, no. 2 (April 1968): 1–11.

MCCOY 1973 McCoy, Garnett, ed. *David Smith*. New York and Washington, D.C.: Praeger Publishers, 1973.

SMITH 1954 (Winter) Smith, David. "Thoughts on Sculpture." *College Art Journal* XIII, no. 2 (Winter 1954): 97–100.

SMITH 1954 (Spring) Smith, David. "Second Thoughts on Sculpture." *College Art Journal* XIII, no. 3 (Spring 1954): 203–207.

SMITH 1960 Smith, David. "Notes on My Work." *Arts* 34, no. 5 (February 1960): 44–49.

SMITH 1968 Smith, David. "Memories to Myself." *Journal of the Archives of American Art* 8, no. 2 (April 1968): 11–16.

SMITH 1969 Smith, David. "Notes for David Smith Makes a Sculpture." *ARTnews* 67 (January 1969): 46–48. Edited by Cleve Gray.

WILKIN 1981 Wilkin, Karen. *David Smith, the Formative Years: Sculptures and Drawings from the 1930s and 1940s* (exhibition catalogue). Edmonton, Alberta: The Edmonton Art Gallery, 1981.

WILKIN 1984 Wilkin, Karen. *David Smith*. New York: Abbeville Press (Modern Masters Series), 1984.